PHOTO-POETICS

Claudia Angelmaier

Erica Baum

Anne Collier

Moyra Davey

Leslie Hewitt

Elad Lassry

Lisa Oppenheim

Erin Shirreff

Kathrin Sonntag

Sara VanDerBeek

Jennifer Blessing

Photo-Poetics:
An Anthology

GUGGENHEIM

Published on the occasion of the exhibition
Photo-Poetics: An Anthology
Organized by Jennifer Blessing with Susan Thompson

Deutsche Bank KunstHalle, Berlin
July 10–August 30, 2015

Solomon R. Guggenheim Museum, New York
November 20, 2015–March 23, 2016

This exhibition is supported in part by Affirmation
Arts Fund and The Robert Mapplethorpe Foundation.

The Leadership Committee for *Photo-Poetics:
An Anthology* is gratefully acknowledged for its
support, with special thanks to Erica Gervais and
Ted Pappendick and Chair Rona Citrin as well as
to Angelo K H Chan and Frederick Wertheim,
Manuel de Santaren, Ann and Mel Schaffer, Patty
and Howard Silverstein, and Cristina von Bargen.

Additional funding is also provided by the Solomon R.
Guggenheim Museum's Photography Committee.

ISBN 978-0-89207-521-8

Guggenheim Museum Publications
1071 Fifth Avenue
New York, New York 10128
guggenheim.org

Available through
ARTBOOK | D.A.P.
155 Sixth Avenue, 2nd Floor
New York, New York 10013
Tel: 212 627 1999; fax: 212 627 9484
artbook.com

Distributed outside the United States
and Canada by
Thames and Hudson, Ltd.
181A High Holborn Road
London WC1V 7QX
United Kingdom
thamesandhudson.com

Design: Julia Born
Editorial: Domenick Ammirati, Kara Pickman
Production: Jonathan Bowen, Melissa Secondino
Typefaces: Bradford (Laurenz Brunner), Maxima

Printed in Germany
by DZA Druckerei zu Altenburg GmbH

Opposite page:
Sarah Charlesworth
El Dorado (from the series *Objects of Desire 3*), 1986
Silver dye bleach print, face-mounted to acrylic,
106.7 × 81.3 cm
Solomon R. Guggenheim Museum, New York;
Gift, Ann and Mel Schaffer 2008.19

In memory of the life and work of
Sarah Charlesworth

CONTENTS

Photo-Poetics: An Anthology presents a focused study of ten influential contemporary artists whose work in photography, film, and video examines photographic representation itself. Taking various conceptual approaches, these artists employ techniques such as appropriation, re-photography, and studio-based still life to ponder media culture, materiality, and subjectivity. The Guggenheim is proud to present this thought-provoking assessment of a major development in the art of the twenty-first century.

My deep appreciation and admiration goes to Jennifer Blessing, whose leadership as the Guggenheim's Senior Curator, Photography, has shaped the museum's robust collection and exemplary exhibition program in the field of photography for the last decade. With this volume and exhibition, Blessing lucidly distills the manifold inquiries that drive some of today's most gifted practitioners in the discipline. I would also like to acknowledge Susan Thompson's contributions to the realization of this project.

The Robert Mapplethorpe Foundation has been a longtime stalwart champion of the Guggenheim's photography program and collecting efforts, and we are most grateful for its crucial support of this endeavor. We also extend heartfelt thanks to Affirmation Arts Fund and the dedicated members of the *Photo-Poetics* Leadership Committee for making this exhibition possible, including Erica Gervais and Ted Pappendick, Chair Rona Citrin, Angelo K H Chan and Frederick Wertheim, Manuel de Santaren, Ann and Mel Schaffer, Patty and Howard Silverstein, and Cristina von Bargen. Additionally, we would like to thank the Guggenheim's Photography Committee for its support of this exhibition and steadfast commitment to the museum's photography program and collection building.

I convey my regards to our colleagues at the Deutsche Bank KunstHalle, Berlin, for participating as a host venue as part of the exhibition's international tour. I wish to acknowledge in particular Friedhelm Hütte, Global Head of Art, Deutsche Bank, for his important early support of the project.

The Guggenheim's deepest gratitude goes to the ten inspiring artists whose work comprises this exhibition: Claudia Angelmaier, Erica Baum, Anne Collier, Moyra Davey, Leslie Hewitt, Elad Lassry, Lisa Oppenheim, Erin Shirreff, Kathrin Sonntag, and Sara VanDerBeek. Each of these artists has made compelling contributions to the discourse of contemporary photography, and we thank them for their contemplative work that so generously rewards our attention.

Richard Armstrong
Director
Solomon R. Guggenheim Museum
and Foundation

ACKNOWLEDGMENTS

The form of this exhibition began to take shape more than five years ago. In the course of identifying potential acquisitions for the Guggenheim's collection, we were developing a critical mass of lucid and cogent contemporary photographs, all notable for their attentiveness to craft. During the same period, people who care deeply about the medium—photo historians, curators, and artists—were convening think tanks to discuss the effects of the digital revolution. The confluence of this introspective moment in the field, and a fresh artistic vision, is manifested in *Photo-Poetics: An Anthology*. I am grateful primarily to the artists in the exhibition, most of all for creating the work that led to the conception of this project, but also for sharing their time and insight. There is little in the job of the contemporary curator that is more fulfilling than to be in the studio, in dialogue with artists, and this group of practitioners is especially generous, thoughtful, and thought-provoking.

I am also grateful to have had the opportunity to participate in contemporary photography symposia at the Museum of Modern Art, New York (MoMA), and the San Francisco Museum of Modern Art (SFMOMA) in early 2010, during the period when I was formulating my ideas for *Photo-Poetics*. I thank my colleagues at MoMA, Roxana Marcoci and Eva Respini (now at Institute of Contemporary Art, Boston), and at SFMOMA, Corey Keller and Sandra S. Phillips, for their kind invitations, and the stimulating intellectual forums they have provided. I look forward to continuing these important discussions in the context of the educational programming around the present exhibition. We intend to engage some of the curators and critics who are cited in my footnotes and in the suggested reading lists, given their commitment to the artists and issues addressed herein.

In a small but important way, *Photo-Poetics* commemorates the activities of the Guggenheim's photography acquisition committee during the last decade. The Photography Committee was formed in 1998 upon a mandate furnished by the Robert Mapplethorpe Foundation accompanying its gift of nearly two hundred canonical Mapplethorpe artworks as well as funds to support photography programming at the museum. The mission of the Photography Committee is to collect conceptually based contemporary photography, with a broadly interpreted notion of the medium as an ever-mutating recording technology. Since the committee's inception, the group and its individual members have given more than 350 photographs and videos to the collection. This exhibition was born, in part, out of the acquisition presentations my colleague Nat Trotman and I have made to the Photography Committee over the last several years. In the process of identifying works for the collection, and arguing for their importance, we have repeatedly pointed out that these artists' pieces represent a new and significant direction in contemporary practice. We are gratified by the dedication of all the committee members, and by the guidance of its stalwart co-chairs Manuel de Santaren, Ann Schaffer, and Aaron Tighe.

The committed and enthusiastic art lovers on the Photography Committee have also supported photo-based exhibitions at the museum, including this one. Our lasting appreciation goes to Michael Ward Stout, who sits on the committee as the president of the Robert Mapplethorpe Foundation, along with the Leadership Committee for *Photo-Poetics: An Anthology*, spearheaded by Rona Citrin, with special thanks to Erica Gervais, Angelo Chan, Manuel de Santaren, Ann and Mel Schaffer, Patty Silverstein, Cristina von Bargen, Lauren Baker Pinkus, Barbara Toll, Lisa S. Miller, and Louise Puschel.

While the exhibition and many of my essays in this catalogue focus on artworks that were brought into the museum's permanent collection through the good offices of Photography Committee members, *Photo-Poetics* has been greatly enriched by the loans of important pieces by each of the artists included in the show. We would like to thank all the exhibition's lenders for their kind generosity, specifically: Claudia Angelmaier; The Approach, London; Laura Belgray and Steven Eckler; Tanya Bonakdar Gallery, New York; Bureau, New York; Michael Clifton; Beth Rudin DeWoody; Cheryl Donegan and Kenneth Goldsmith; Arthur and Susan Fleischer; Edward and Francine Kittredge; David Kordansky Gallery, Los Angeles; Jenny and Trey Laird; Sheri B. Levine; Scott J. Lorinsky; Arlene Mark; Metro Pictures, New York;

Murray Guy, New York; The Museum of Modern Art, New York; Andrew Ong and George Robertson; Yancey Richardson; Ann and Mel Schaffer; Erin Shirreff; The Frances Young Tang Teaching Museum and Art Gallery, Skidmore College, Saratoga Springs, New York; Aaron and Kimberly Tighe; Jean-Edouard van Praet; and anonymous lenders.

A project like this would never come to fruition without the support of the museum's administration. I am most grateful to Richard Armstrong, Director, and to Deputy Director and Jennifer and David Stockman Chief Curator, Nancy Spector, for their encouragement and guidance. I would like to join the director in recognizing Friedhelm Hütte, Global Head of Art at Deutsche Bank, for arranging the Berlin venue of the show at the Deutsche Bank KunstHalle. It is a fitting location as several of the artists, and the catalogue's designer, have lived, or currently live, in this fascinating city. It is always a pleasure to work with the consummate professionals at the KunstHalle, Sara Bernshausen and Svenja Gräfin von Reichenbach.

My colleagues in the Guggenheim's curatorial department are a constant source of inspiration. Without the expert help of Assistant Curator Susan Thompson, I quite literally could not have organized this exhibition and catalogue. She has also con- tributed astute and concise biographical entries on each of the ten artists. Over the last several years, this project has benefited from the collegial advice of other curatorial coworkers, including especially Nat Trotman, Associate Curator; Joan Young, Director, Curatorial Affairs; and Lauren Hinkson, Assistant Curator for Collections. Many interns have been integral to its realization, as well, most recently and extensively Rodrigo Guzmán and Theresa Hioki, but others who provided relevant research include Dmitry Komis, Amy Raffel, Jacqueline Sischy, and Chelsea Spengemann.

Every Guggenheim staff member has at least indirectly impacted this project; however those who have played a direct, crucial role are listed on the following pages. I am eternally grateful for the opportunity to work with such a talented and dedi- cated group of professionals. For *Photo-Poetics*, I am especially indebted to conservator Jeffrey Warda for his attention to the photographs in the collection, as well as the marvelous artist interviews he con- ducts. The expertise of conservator Joanna Phillips has also been a critical resource. Melanie Taylor has created elegantly well-structured installations for Berlin and New York that perfectly capture the anthological formation of the exhibition, as a show- case for each artist's unique practice.

From the start, this catalogue was fundamental to the exhibition's conception. The artists in the show share an interest in the materiality of the photo- graphic image, and some also create artist's books, so it was essential that the catalogue not only be a physical object, but one that reflected the history of photo-conceptual artist's books as well. The designer, Julia Born, has exceeded my expectations for an anthology, allotting equal space to each artist just as we have done with the exhibition installation. I am grateful to have had the good fortune to work with Elizabeth Levy, former Managing Director, Publishing and Digital Media, for more than twenty years, and to have known editor extraordinaire Domenick Ammirati for almost as long. I thank them for making sure this book got off the ground, and hope to work with them again in the future. Elizabeth Franzen, Melissa Secondino, Jonathan Bowen, and Kara Pickman have ably seen the project through to the pages you are now reading.

Many colleagues outside the museum have helped in myriad ways, supplying information about artists, artworks, and reproductions. I would like to thank the following individuals for graciously sharing their expertise: Lesley A. Martin at Aperture, New York; Malik Al-Mahrouky and Emma Robertson at the Approach, London; Stephen Gribbin at Art Agency, Partners, New York; Alex Glauber at AWG Art Advisory, New York; Joel Draper and Emily Ruotolo at Tanya Bonakdar Gallery, New York; Maliea Croy, Gabrielle Giattino, and Mary Grace Wright at Bureau, New York; Wendy Grogan; Tappan Heher; Melissa Timarchi at Leslie Hewitt's studio; Joanna Kamm; Jasmin Chun, Christoph Gerozissis, Jenny Gerozissis, and Courtney Treut at Anton Kern Gallery, New York; William Parks at David Kordansky Gallery, Los Angeles; Lauren Wittels at Luhring Augustine Gallery, New York; Allison Card and Margaret Zwilling at Metro Pictures, New York; Quentin Bajac, Lucy Gallun, and Tasha Lutek at the Museum of Modern Art, New York; Sonel Breslav and Janice Guy at Murray Guy, New York; Lia Lowenthal at Lisa Oppenheim's studio; Scott Briscoe, Matthew Droege, and Meg Malloy at Sikkema Jenkins & Co., New York; Ian Berry, Elizabeth Karp, Sarah G. Miller, and Rachel Seligman at the Frances Young Tang Teaching Museum and Art Gallery, Skidmore College, Saratoga Springs, New York; Lucien Terras; Cristian Alexa at 303 Gallery, New York; and Phoebe Streblow at Sara VanDerBeek's studio.

This catalogue is dedicated to the memory of Sarah Charlesworth, whose life and work has affected me, and influenced this project, in many ways, small and large, personal and art-historical. Sarah's death on June 25, 2013, was premature, and yet she left legacies—as an artist, educator, mother, and feminist—that will ensure that her spirit lives on. Traces are preserved in this book in the references to her work, both textual and visual, and in the memories of those of us who had the privilege of knowing her.

Jennifer Blessing
Senior Curator, Photography

PROJECT TEAM

ART SERVICES AND PREPARATION
David Bufano, Director, Art Services and Preparation
Barry Hylton, Senior Manager, Exhibition Installations
Elisabeth Jaff, Senior Preparator

DEVELOPMENT
Catherine Carver Dunn, Deputy Director, Advancement
Mary Anne Talotta, Director of Individual Giving, Major Gifts
Kerri Schlottmann, Director, Institutional Development
Paola Zanzo-Sahl, Director, Special Events
Lili Rusing, Manager, Institutional Development
Halsey H. Stebbins, Manager, Individual Development
Emma Rippee, Manager, Special Events

CONSERVATION
Jeffrey Warda, Conservator, Paper and Photographs
Joanna Phillips, Conservator, Time-based Media

CONSTRUCTION
Richard Burgess, Former Head of Exhibition Construction, and the team

CURATORIAL
Jennifer Blessing, Senior Curator, Photography
Susan Thompson, Assistant Curator
Rodrigo Guzmán and Theresa Hioki, Curatorial Interns

EDUCATION
Kim Kanatani, Deputy Director and Gail Engelberg Director of Education
Sharon Vatsky, Director of School and Family Programs
Christina Yang, Director of Public Programs
Jennifer Yee, Manager, Academic and Public Programs
Alyson Luck, Manager of School, Youth, and Family Programs

EXHIBITION DESIGN
Melanie Taylor, Director, Exhibition Design
Christine Rung, Exhibition Design Coordinator

EXHIBITION MANAGEMENT
Jennifer Bose, Director of Exhibition Management
Cate Griffin, Exhibition Manager

FABRICATION
Christopher George, Associate Director of Facilities, and the team

FACILITIES
Peter Read, Director of Facilities and Office Services, and the team

FINANCE
Marvin Suchoff, Chief Financial Officer
Lesley Lana, Budget Manager
Dafna Landau, Senior Financial Analyst

GRAPHIC DESIGN
Marcia Fardella, Director, Graphic Design and Chief Graphic Designer
Janice I-Chiao Lee, Associate Director, Graphic Design
Peter Raphael Castro, Associate Graphic Designer and Production Manager, Graphic Design

INTERACTIVE
Maria Slusarev, Associate Director, Interactive
Jake Davis, Assistant Web Editor
Josie Rubio, Interactive Producer

LEGAL
Sarah Austrian, Deputy Director, General Counsel and Assistant Secretary
Marianna Horton Mermin, Associate General Counsel
Lee White Galvis, Associate General Counsel

LIBRARY AND ARCHIVES
Francine Snyder, Former Director of Library and Archives
Jillian Suarez, Assistant Librarian

LIGHTING
Mary Ann Hoag, Head of Exhibition Lighting

MARKETING AND SOCIAL MEDIA
Laura J. Miller, Director of Marketing
Holly Campbell, Associate Director of Marketing
Jia Jia Fei, Associate Director of Digital Marketing
Essie Lash, Marketing Manager
Grace Franck, Digital Marketing Associate
Shama Rahman, Marketing Associate

MEDIA AND PUBLIC RELATIONS
Sarah Eaton, Director, Media and Public Relations
Lauren Van Natten, Associate Director, Media and Public Relations
Kristina Parker, Senior Publicist
Molly Stewart, Publicist

PHOTOGRAPHY
David Heald, Director of Photographic Services
Kristopher McKay, Photographer and Studio Manager
Owen Conway, Image Archive Associate

Introductions

Photo-Poetics: An Anthology documents a development in art of the past decade. The ten artists in the exhibition contemplate the nature, traditions, and magic of photography at a moment characterized by its rapid digital transformation. They rematerialize the medium through meticulous printing, using film and other disappearing photo technologies, and by creating photo-sculptures, installations, and artist's books. While they are invested in exploring the processes, supports, and techniques of photography, they are also deeply interested in how photographic images circulate. Theirs is a sort of "photo poetics," an art that self-consciously investigates the laws of photography and the nature of photographic representation, reproduction, and the photographic object.

These artists pursue a largely studio-based approach to still-life photography that centers on the creation of images *as* objects, as well as on the representation of image-bearing printed matter—books, magazines, record covers, and snapshots. They are drawn to appropriate these items for diverse reasons, ranging from the cultural and historical significance of the photographs to the personal associations they evoke.

At various moments in the gestation of the exhibition for which this volume serves as a catalogue, it was titled "Post-Pictures" or "The Rematerialization of the Photograph." The former title references the profound influence that the Pictures generation critique of the image has had on all the artists in the show, while the latter signals a contemporary rethinking of the Conceptual art of the 1960s and '70s, specifically its characteristic "dematerialization of the object."[1] Both invoke not only the conceptual nature of photography but also the inspiration provided for the younger generation by the work of the artists associated with these histories. *Photo-Poetics* aspires to acknowledge these precedents while allowing for the variety and complexity of the practices it

1 See Douglas Crimp, "Pictures," in *Pictures* (New York: Committee for the Visual Arts, 1977); and Crimp, "Pictures," *October* 8 (Spring 1979), pp. 75–88. See also Lucy R. Lippard with John Chandler, "The Dematerialization of Art," in *Art International* 12, no. 2 (February 1968), pp. 31–36; and Lippard, *Six Years: The Dematerialization of the Art Object from 1966 to 1972* (New York: Praeger, 1973). Lippard's project, as articulated by Cornelia Butler, has inspired the conceptualization of *Photo-Poetics*; see Butler, "Women—Concept—Art: Lucy R. Lippard's Numbers Shows," in *From Conceptualism to Feminism: Lucy Lippard's Numbers Shows 1969–74* (London: Afterall, 2012), pp. 16–69. See also Alex Klein, "Remembering and Forgetting Conceptual Art," in *Words Without Pictures* (New York: Aperture, 2010), pp. 120–31.

gathers together.[2] Both the exhibition and this catalogue are conceived as anthologies, as vehicles to introduce each artist's important practice. This volume documents the exhibition, and its design is intended to recall these practitioners' commitment to the craft of photography, for which the book has always been a primary means of communication.

The works in *Photo-Poetics*, rich with detail, reward close and prolonged regard; they ask for a mode of looking that is closer to reading than the cursory scanning fostered by the clicking and swiping functionalities of smartphones and social media. Therefore the ten short monographic essays published here attempt to demonstrate—to model—this form of engagement through close readings of select pieces in the show. In addition to more forensic descriptions and assays of the artists' intent, I have chosen at times to venture interpretations based on more personal impressions of the affective aspects of the work—the way that certain elements speak to me, as one reader-viewer.

In the end, these artworks, and the exhibition *Photo-Poetics*, are literary, about creating texts and reading as well as literally about books. Each of the essays provides a point of entry for understanding a particular photograph. You are free to read them in any order you like, as they are intended to be read independently; cumulatively they inform the impassioned conclusions outlined in the Afterwords (p. 137). Any misreadings or other misunderstandings are entirely the responsibility of the author.

2 Catalogues of recent group exhibitions that address some of the issues of appropriation proposed by Pictures generation artists and feature several of the artists in *Photo-Poetics* include Matthew Thompson, et al., *The Anxiety of Photography* (Aspen, Colo.: Aspen Art Press, 2011), which features Leslie Hewitt, Elad Lassry, Erin Shirreff, and Sara VanDerBeek; Sara Krajewski, *Image Transfer: Pictures in a Remix Culture* (Seattle: Henry Art Gallery, 2010), including Lisa Oppenheim and VanDerBeek; and Fionn Meade, et al., *Knight's Move* (Long Island City, N.Y.: Sculpture Center, 2010), featuring Shirreff and VanDerBeek.

Claudia Angelmaier

Betty, 2008

GEBR. KÖNIG POSTKARTENVERLAG · BREITESTR. 93 · D-50667 KÖLN · PRINTED IN GERMANY

GERHARD RICHTER
Betty, 1988

Serie 218 *Gerhard Richter*
Karte 7 von 10

Bestell-Nr. 218/7

From afar, Claudia Angelmaier's *Betty* (2008), from her ongoing series *Works on Paper*, reads as a shiny, monochromatic white surface. On closer inspection, a kind of palimpsest portrait appears, a young woman or girl twisted in contrapposto, looking away from the viewer and into a gray-green void. Bleached hints of her lively red floral top activate the lower half of the picture, which is delineated by an upside-down line of type:

GEBR. KÖNIG POSTKARTENVERLAG · BREITESTR. 93
D-50667 KÖLN · PRINTED IN GERMANY.

German readers will recognize the imprint of a major European publisher of contemporary-art postcards, along with the company's address in Cologne.[1] On the lower left vertical axis is the name of the author of the portrait, Gerhard Richter, along with its title, the same as Angelmaier's, and a date twenty years prior.

This photograph of a postcard held against a light source (probably resting on a photographer's lightbox) shows the image printed on the front of the card as faintly visible through its reverse side. The central line of type divides the upper half of the card, designated for a recipient's mailing address, from the lower section, intended for the sender's message. This typographic line neatly separates the figure's head from her body, as if to mark the picture's perfect proportions, like the demarcations defining Leonardo's Vitruvian Man.

Betty, a famous work by a famous contemporary artist, has been endlessly replicated and parodied. Its power resides in part in its enigmatic nature. Questions revolving around the subject of the painting, whose face is unseen, complicate the central conundrum of the work, which surrounds its medium: is this a photograph or a painting,

1 Gebrüder König refers to the brothers Walther and Kasper König, publisher and museum director, respectively, who are supporters and in many cases personal friends of German artists of their generation. The postcard is 1/7 in series 218 of Gebr. König cards dedicated to Richter, as its legend indicates.

document or invention? Learning that the sitter is the artist's daughter doesn't satisfy the desire to answer these questions, or to see her face. A child poised on the brink of adulthood, the transitional status of her adolescence only enhances the ambiguity of the image. In fact, Richter made his painting in 1988 from a photograph taken in 1978, when his daughter was eleven years old. Thus the painting is haunted by the memory of his daughter as a girl, a quality that is captured by the clearly photographic focus, its lovingly attentive and felicitous realism. In 1991, Richter produced an editioned print after the painting, creating a spiraling mise en abyme of photo-painting-reproduction, in a trajectory typical of his practice.[2]

Angelmaier, exploring the reproduction and circulation of works of art, harnesses this unique history. While she has appropriated a postcard by rephotographing it, she has not maintained its original size. Instead, her *Betty* replicates the scale of Richter's painting, in which the sitter is approximately life size. In the process, her piece highlights the way that (photographic) reproduction changes our perception of an artwork, making it more accessible not only through the easy availability of the copy but also via its portability and the capacity to hold it in our hands. Postcards, along with reproductions in books, posters, and slides (first glass, then film), have for more than a century been the means by which art lovers, artists, and historians first encountered works or retained the impression of favorite pieces. With the rise of digital files and the Internet, these physical forms of communication and collecting have been largely replaced by the virtual. And yet at this moment, postcards of Italian Renaissance Madonna-and-child paintings hang on the wall in front of my desk, talismanic emblems of maternal love, they are too personally precious to mail.

Angelmaier's enlarged postcard retains a stubborn insistence on the pleasure of the physical encounter with an actual work of art, not only through its scale and the ethereal yet rigorous beauty of its conception but also by the way the photo is presented, face-mounted to an acrylic panel. This technique, ubiquitous in the late 1990s, allows

2 See https://www.gerhard-richter.com/en/art/paintings/photo-paintings/children-52/betty-7668 (accessed October 14, 2014) for an image of the painting, which measures 102 × 72 cm. The work is based on a photo on sheet 445 of Richter's *Atlas*, called "Various Motifs," from 1978. For the related print, which is slightly smaller in scale, see https://www.gerhard-richter.com/en/art/editions/betty-12767/?&p=4&sp=32. It is interesting to note that the reversed image calls to mind the eponymous figure in Andrew Wyeth's famous realist painting *Christina's World* (1948).

LOUVRE Département
des Peintures

II

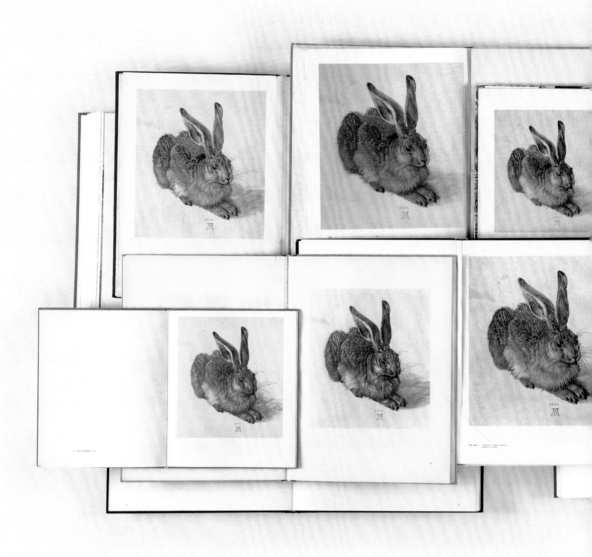

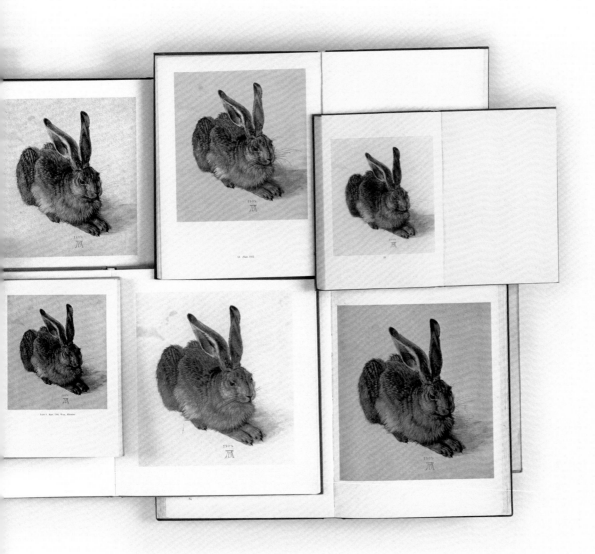

Ingres
1780–1867

La petite baigneuse, Intérieur de Harem, 1828
Toile
0,35 × 0,27 m
Acquis en 1908

LOUVRE Département
des Peintures

large-scale photographs to be shown without matting or framing, thus taking on the form and size of painting as well as some of the luminosity of cinema and the reflective glassiness of a computer or television screen.[3] Unlike the previous generation of German photographers, such as Andreas Gursky, Candida Höfer, and Thomas Struth, who perfected this stylistic device, however, Angelmaier's practice is rooted in the studio rather than the street. While her predecessors sought to rival large-scale painting through their photographs, often depicting social spaces, her pictures ask questions about the nature of photographic reproduction. She seems at least as interested in how the image circulates as in the image itself.

Angelmaier's *Works on Paper* series largely focuses on postcard reproductions of female bathers viewed from the back, a traditional theme in the history of art that the pose of Richter's *Betty* recalls.[4] She draws attention to the voyeuristic fantasy embodied in the motif, a discreet but also tantalizing form of nudity, by creating a similar dynamic: the clarity of the reverse of the postcards only enhances the viewer's desire to clearly see its obverse.[5] The tension between text and image in the series further frustrates. Focusing on the typography makes it impossible to see the image, and a clear perception of the image reduces the text to a linear diagram. This dialectic is embodied in the work itself, in a critical edge tempered by what is essentially an act of homage. It speaks to the capacity of art to entertain multiple (and contradictory) meanings and interpretations at once. One may lament the prevalence of representations of female subjects as objects rather than producers while at the same time enjoying a particular depiction, or bemoan the loss of art's aura via the humble and imperfect postcard (not to mention the Internet) while acknowledging the collector's delight in these surrogates. Arguably, the accessibility and familiarity that reproductions afford only enhance the desire to experience them in person.

The apparition-like nature of the bathers and other recalcitrant figures in Angelmaier's *Works on Paper* signal the legions of ghosts that

3 Angelmaier prints her photographs at the Grieger photo lab in Düsseldorf where this process was perfected.

4 In fact, Richter's *Betty* is based on Jean-Auguste-Dominique Ingres's *Valpinçon Bather* (1808), a reproduction of which he kept in his studio. Angelmaier has created two photographs based on postcards of Ingres's work.

5 Angelmaier's series also calls to mind the category of "French postcards" and the historical definitions of obscenity emanating from the United States Postal Service.

haunt the images; not only their stubborn subjects, who endlessly refuse to turn, and the artists who created them (Richter as well as Man Ray and Ingres), but also those whose conceptual gestures Angelmaier engages—Marcel Duchamp, with his small reproductions of his own work in the *Boîte-en-Valise* (1935–41), for example, or Sherrie Levine, with her groundbreaking photographs of book plates, such as the series *After Rodchenko* (1987). Though Angelmaier's *Betty* is a pleasure to behold in itself, the complexity of its references provides an intellectual supplement with its own rewards. Her postcard pieces represent a literal site of exchange between an author and a reader, a metaphor for the work of art as a site similar for both artist and viewer, a call that elicits a response. As a female artist, both producer and consumer of the images she appropriates—images that feature women as subject and object—Angelmaier seems invested in collapsing these binaries. Hers is an act of filial piety that simultaneously blurs the lines between teacher and student, parent and child.

fotofolio

VIOLON D'INGRES, 1924
PHOTOGRAPH BY MAN RAY

© FOTOFOLIO, BOX 661 CANAL STA., NY, NY 10013
ISBN 1-881270-62-9
MR5

CLAUDIA ANGELMAIER

Taking art-historical masterpieces—and, by extension, art history itself—as her referents, Claudia Angelmaier traces the photographic representation of artworks across the pages of textbooks, classroom slides, coffee table monographs, and postcards. Cognizant that major artworks are most often encountered via reproduction rather than in person, she highlights the analogue media that have facilitated the circulation of such images for many decades. Angelmaier's first major body of work, the series *Plants and Animals* (2004), depicts arrangements of art books opened to different reproductions of the same work by iconic German artist Albrecht Dürer. *Hase* (2004), from this series, shows multiple images of a Dürer watercolor of the same name, the repetition emphasizing subtle variations in color, scale, and resolution. Angelmaier's more recent, ongoing *Works on Paper* series features the backlit versos of museum shop postcards. The artwork pictured on a card's front appears muted yet faintly discernible, while the caption information and museum insignia on the back remain fully legible. Angelmaier was born in 1972 in Göppingen, Germany. She studied geography and English at the University of Erlangen-Nuremberg and Heidelberg University, and received an MA in art history from the Technical University of Berlin. She went on to earn a diploma in fine art/photography in 2006 from the Academy of Visual Arts, Leipzig, where she pursued postgraduate studies. Angelmaier lives and works in Berlin.
— Susan Thompson

SUGGESTED READING

Claudia Angelmaier: L'image et l'objet. Exh. cat. Linz: Landesgalerie; Salzburg: Fotohof, 2009. With essays by Stefanie Hoch and Martin Hochleitner (English and German).

Dillon, Brian. "Claudia Angelmaier: Reproduction Art." *Aperture*, no. 192 (Fall 2008), pp. 56–58.

Schmidt, Hans-Werner, ed. *Claudia Angelmaier: Color and Gray.* Exh. cat. Leipzig: Museum der bildenden Künste; E.A. Seemann, 2007. With essays by Florian Ebner, Schmidt, and Friedrich Tietjen (English and German).

PLATES

I
Betty, 2008
Chromogenic print, face-mounted to acrylic,
130 × 100 cm

II
La Baigneuse Valpinçon, 2008
Chromogenic print, face-mounted to acrylic,
193 × 144.5 cm

III
Hase, 2004
Chromogenic print,
110 × 200 cm

IV
La petite Baigneuse, 2008
Chromogenic print, face-mounted to acrylic,
56 × 42 cm

V
Violon d'Ingres, 2005
Chromogenic print,
130 × 100 cm

Erica Baum

Jaws, 2008

Nebulous 55, 2011

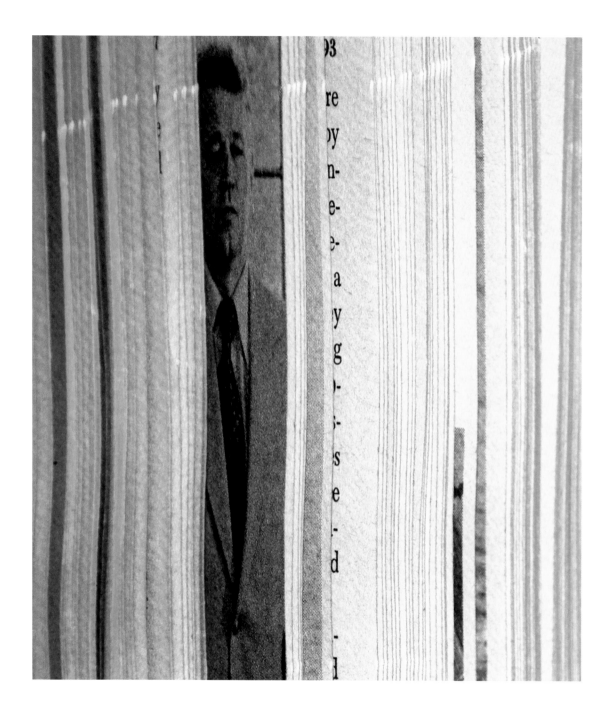

A forlorn man is stuck in a riffled-open book. He looks familiar. He's an actor, but his name doesn't come to mind immediately. Clues: the photograph is titled *Jaws*, à la the 1975 blockbuster film; a thin vertical edge of water is visible on another page. Gradually, a memory surfaces (or a quick Internet search reveals): this actor plays the mayor of the beach town terrorized by a great white shark. The image is a film still.

The book is spread open only enough to reveal the end of each line of text on one page. This column of letters flanks the actor at right, paralleling his prominent cleft chin and necktie. It's tempting to try to read the letters, to crack their code, to create new words vertically or fill in the missing letters across. The presentation transforms each letter into a lovely abstract vignette, the serif font appealing in itself. There seem to be an unusual number of hyphens; the dashes, enlarged, feel carved and weighty. A horizontal crack in the wall behind the man is perpendicular to his nose, an *n-* is on the same axis as the crack.

The book looks old, perhaps as old as the movie. Its pages are yellowed but enlivened by turquoise edging. Color photography documents the present condition of the book in contradistinction to the black-and-white photomechanically reproduced man, both image and person now things of the past. A jagged scratch courses along the edge of the volume's pages, raking across the actor's forehead. A reader's fingernail dragged along the edge while flipping through it? In the summer of '75, when *Jaws* was released, it generated hysteria among moviegoers living in the coastal United States, who feared swimming in the ocean. The scratch's jagged trail defaces the book, violently disrupting its precise vertical and horizontal axes, wounding the man in its path and recalling a violent rip, the slash of a knife, the gash of a shark bite.

The book has been positioned very close to the camera. Each letter is magnified to about three times its usual size. The grain of the paper is palpable, the curving sheets voluptuous. Less an object to look at than a space to enter, the volume's blue edges open onto the vistas of its interior. The viewer is invited to enter the world of the book, which is the world of the pictured man, a visual metaphor for the experience of reading, for getting lost in a story, totally immersed in its narrative.

Jaws (2008) is one of the first photos in Erica Baum's ongoing series *Naked Eye*, named for eyewitness accounts of UFO sightings that purport to provide firsthand, incontrovertible evidence of alien life.[1]

1 Baum notes the popularity of books about UFOs in the 1960s and '70s, and that she used such a book for one of the first *Naked Eye* pictures, in Erica Baum, "Dog Ear Poems,"

As records of events, both photographs and witness testimony are often unreliable and can be manipulated. But Baum's allusion seems intended less to question the accuracy of memory than to celebrate the rich imaginations that produce sightings of spacecraft from ambiguous visual phenomena. Her interest lies more in the process of creating narratives—reading the skies, or photographs without captions, or fragments of texts—in order to find fractured meaning and oneiric beauty in colliding bits of a-sensical information, signifiers in a jumble with unfixed signifieds.

Baum approaches the subjects of her photographs like an anthropologist studying the popular culture of the 1960s and '70s of her youth. Shot from cheap paperbacks—predominantly movie tie-ins, true-crime stories, and political bios—most of the images in the *Naked Eye* series feature portraits of public figures. Some of these celebrities, gangsters, and politicians are recognizable (at least to a person around the age of the artist), or else the works' titles give clues that help to identify them, as with *Jaws* and *Bonnie* (featuring a postmortem image of one half of the outlaw duo Bonnie and Clyde). Other titles are more generic descriptors of a figure's occupation (*Referee, Gangster, Army Nurse*), objects being used (*Telephone, Towel, Cigarette*), or verbs that describe the depicted activity or reaction (*Slept, Alarmed*). Blond stars and starlets predominate, from Goldie Hawn and Brigitte Bardot in Baum's *Shampoo* and *Shift*, respectively, to numerous elaborately coiffed, vaguely familiar young women labeled with first names that may be their own or that of the character they are playing.[2]

For Baum, the snippets of text in the *Naked Eye* photos can indicate, like a cartoon bubble, "the thoughts of the figure caught inside the book."[3] Her characters are always absorbed in reflection, or captured in the midst of an action, never breaking the fourth wall, suggesting they have been found where they live, gazing at the page they face, which we cannot see. They are permanently "in character"; thus the photos' titles are perhaps better understood in cinematic context, as the names of actors, movies, stock characters, props, and script directions.[4] This

interview by Cecilia Alemani, *Mousse*, no. 22 (February 2010), p. 107, and "Erica Baum: In the Studio," by Steel Stillman, *Art in America* 101, no. 9 (October 2013), p. 161.

2 The population of men in suits in Baum's photos, as well as the record of female hairstyles they provide, suggest an anthropological investigation of gender presentation in the third quarter of the twentieth century (i.e., during the artist's youth) through the lens of Hollywood.

3 Baum, "Dog Ear Poems," p. 107.

are is the chatter of birds

Parades

slippage between the real and the role is fundamental to the *Naked Eye* works. Though its sources are often ostensibly nonfiction, the books document the fictional worlds of cinema, a simulacrum of reality.[5] Baum appropriates found photos of actors and uses them as a director might, to suggest enigmatic scenes. Her open books are stages on which a play or movie unfolds, while the fragments of texts they contain makes them simultaneously legible as concrete poems.

Through the aleatory process of "spreading," as she puts it, Baum creates "found collages" whose provocative and puzzling juxtapositions generate endless opportunities for recombinant meaning as each reader brings her unique focus to the work.[6] In some photos, whole words are visible, maximizing the effect of poetry when read vertically; others have no text at all, privileging their titles. Some are quite abstract. *Nebulous 55* (2011), one of a subgroup within the *Naked Eye* series shot from a meteorology book, is a medley of glossy, razor-edge inky blue columns initially hard to decipher as what they are: splinters of night skies interwoven with bits of twilight orange and wisps of atmospheric clouds. Its title perhaps best embodies the tone of Baum's work overall. *Nebulous* is a word of complex associations, an adjective derived from the Latin word for cloud, with *nebula* denoting the observable intergalactic phenomenon. Concomitantly, it suggests amorphousness, mutability—the cloudlike. *Nebulous 55* points to the interaction in Baum's work of two principle photographic processes, that of documentation and of appropriation. It also exemplifies the artist's sheer delight in beauty found in the mundane, everyday, clichéd, and discarded.

Baum documents books that are worn and used; they bear proof of their function. She shoots her photos from the point of view of a reader, fanning the book open to reveal its contents. She is not interested in the book as object, shelved in color-coordinated order like in a spread in a shelter magazine, but rather in the potentials that lay between two covers. By focusing on the many pages inside, and in the

4 In fact, two of the books are scripts, with the movie characters' names set in all capital letters.

5 Gangsters and politicians easily fit within this rubric, as public figures who act on the world's stage, and Baum's selections emphasize the theatricality inherent to their representations. Of the latter, for example, *Nixon and Pat* (2009) suggests a sham marriage for political ends (and the Zapruder film of the JFK assassination), and *Reagan* (2013) shows the actor, prepresidential, modeling for a life-drawing class. The true-crime photos in Baum's works tend to read as stills from the gangster-film genre.

6 "Erica Baum: In the Studio," p. 161, and Baum, "Dog Ear Poems," p. 107.

process rejecting the interior's bilateral symmetry, the artist signals to readers the multiplicity of pleasures to be found within her multiplicitous and nebulous texts. There is no single story told, nor one correct way to read.

ERICA BAUM

Erica Baum takes the printed page as her primary subject, photographing fragments of found language at close range. Commingling image and text, her works often operate simultaneously as both photograph and poem. In 1996, Baum began taking photographs of the interiors of library card catalogue drawers, highlighting the by turns humorous or poignant juxtapositions of research topics that arose from the coincidence of alphabetical proximity. A similar instinct guides the 1999–2000 series *Index*, which features Xeroxed combinations of select terms and their subcategories as found in the indices of various books. For the *Naked Eye* series, ongoing since 2009, Baum directs her camera into the partially opened pages of stipple-edged paperbacks from the 1960s and '70s, capturing slivers of imagistic and textual content separated by the vertical striations of adjacent pages' brightly dyed edges. The compositions operate as found collages that veer toward abstraction. The decontextualized lines of text and color that comprise Baum's more recent ongoing series *Newspaper Clippings* are culled from the *New York Times*. Baum combines these appropriated snippets by layering horizontal strips of newsprint into compositions of spare poetry that reflect the tenor of our times. Baum was born in New York in 1961 and received a BA in anthropology from Barnard College, New York, in 1984, an MA in TESOL/applied linguistics in 1988 from Hunter College, New York, and an MFA in photography from Yale University, New Haven, Connecticut, in 1994. Baum lives and works in New York.
— Susan Thompson

SUGGESTED READING

Baum, Erica. *Dog Ear*. Brooklyn: Ugly Duckling Presse, 2011. With essays by Kenneth Goldsmith and Béatrice Gross.

——. "Dog Ear Poems." Interview by Cecilia Alemani. *Mousse*, no. 22 (Feb. 2010), pp. 106–10.

——. "Erica Baum: In the Studio." By Steel Stillman. *Art in America* 101, no. 9 (Oct. 2013), pp. 156–65.

Roll Playing. Exh. cat. Philadelphia: University of Pennsylvania, 2008. With essays by Kenneth Goldsmith and Kaegan Sparks, and an interview with the artist by Sparks.

PLATES

I
Jaws (from the series *Naked Eye*), 2008
Inkjet print, 47 × 41.6 cm

II
Amnesia (from the series *Naked Eye*), 2008
Inkjet print, 43.2 × 38.1 cm

III
Picton Ceiling White Petals Leopard Square Chatter, 2014
Installation of four inkjet prints, 78.7 × 228.6 cm overall

IV
Nebulous 55 (from the series *Naked Eye*), 2011
Inkjet print, 40.6 × 39.4 cm

V
Shampoo (from the series *Naked Eye*), 2008
Inkjet print, 48.3 × 35.6 cm

Anne Collier

Crying, 2005

*Open Book #2
(Crépuscules)*, 2009

Anne Collier's *Crying* (2005) is a photograph in landscape orientation, about one meter high. Crossing the horizon line that divides the black floor from the white vista of the backdrop, tilted slightly away from us like a sailboat tacking into the wind, is a stack of record albums. The clinical precision of Collier's image is disrupted by the photo of a woman crying on the frontmost album, living color in a sea of black and white. Even without the gelatinous tears, her expressive eyes make it obvious that she is distraught; her gaze focuses on a source of sadness that defies words.

On closer inspection, it's possible to read the text on the album's top edge: "FOR WHOM THE BELL TOLLS As performed by..." REINDORF? Or is it HEINDORP? It's hard to say because of the way the angled letters on the spine recede from the lens. "STEREO" is clearly visible, and printed discreetly in white along the lower left edge of the image, "1958 WARNER BROS RECORDS, INC." If I didn't recognize Ingrid Bergman, or did but didn't know which movie this still is from, I now have sufficient information to deduce that this is an orchestral recording (conducted by Ray Heindorf, it turns out) of the score of the 1943 film adaptation of Ernest Hemingway's novel, starring Bergman and Gary Cooper.

An eBay search reveals that I can buy an album like this one for $8.39. Given the price, it is presumably a copy like Collier's, bearing signs of wear and tear, in G rather than VG condition. The album inside has over time rubbed a ring onto the cover of the copy in *Crying*, creating a scar across Bergman's forehead, encircling her jaw and joining the halo of light behind her on the left side of her face. Her parted, full red lips frame a black void like an abyss, echoing the foreground of Collier's photograph. With the woman's image skewed to the left of the composition, the resulting empty space memorializes the absent one for whom she cries.

Crying was shot with a large-format film camera using the conventions of commercial photography. A white border frames the image, revealing that the white background is really gray. The cover image of Bergman is more atmospheric than the photo in which it appears, its soft blurriness suggesting arrested action: Technicolor film stilled. It is reproduced on the album as a full bleed, which gives the illusion of exceeding any frame; in other words, it's not a picture but rather a window or a mirror, a slice of life. This design format is a popular choice for posters, album covers, and magazines, to immerse the viewer

44

in the subject, to heighten impact by bringing the photo closer. Tightly cropped, Bergman's head is approximately life size. She is one of us.

With the sparest of formal means, assisted by the surrogate of a mass-produced printed piece of pop ephemera, Collier conveys a sense of existential loneliness. She has described her work as "a kind of deflected self-portraiture," and most typically her appropriated images depict fair-haired, blue-eyed women such as herself, often with tragic backstories.[1] Ingrid Bergman is a perfect example: like Collier, she was orphaned at a relatively young age, as is her character in *For Whom the Bell Tolls*. Collier has referred to paired seascapes of the place where her parents' ashes were scattered (*Jim and Lynda*, 2002) as metaphorical portraits of them. The emptiness within *Crying* suggests a similar ghost portrait of the character Cooper plays in the 1943 film, Bergman's doomed lover, but the space also becomes a blank slate on which the artist writes her own grief (and we, in turn, write ours). Though immortalized through photography, Bergman's image is (literally) dated 1958, a year Collier's parents were alive before her. Thus the actress appears not only as a mirror for the artist but also, obliquely, as a mother who cries for her child.[2]

While this knowledge of Bergman's and the artist's biographies enhances an understanding of the piece, it is not essential. The title, *Crying*, says it all: the gerund form of a verb standing alone, it presupposes neither a specific subject nor a particular temporality. While the work speaks of the artist's individual experience, it is also universal. It announces that, at its core, the experience that is depicted, the action represented, is the expression of affect. Contained within a velvety, painterly little square, the act of crying punctures the precise regimented space.

As Collier photographs printed objects such as album covers, books, magazines, and posters—a common tactic in her oeuvre—she combs through the archive of mass-media portraits of women of certain types: crying blondes, female artists, and ads featuring women with

1 "Anne Collier," interview by Aimee Walleston, *The Last Magazine*, no. 1 (Fall 2008), p. 14.

2 In this regard, it may also be significant that, like the artist's mother, Bergman died of breast cancer. Interestingly, in the film, Bergman's character frequently mentions her devotion to her lost parents, who were executed. She equates her love for Cooper's character to that for her father, and finds a surrogate mother in an unusual, heroic female Republican guerrilla leader. One of Cooper's last lines to her, around the moment captured in the album-cover still, is "You're all there will ever be of me now."

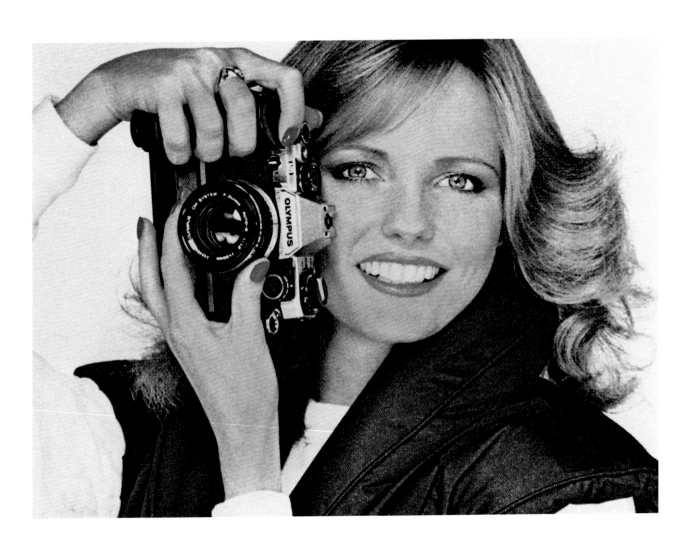

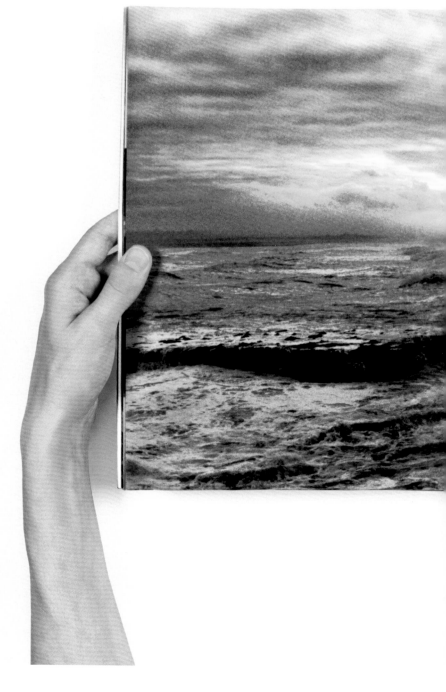

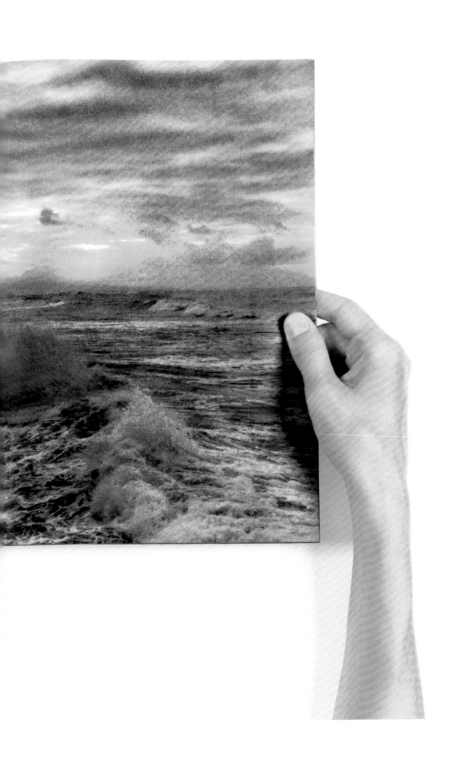

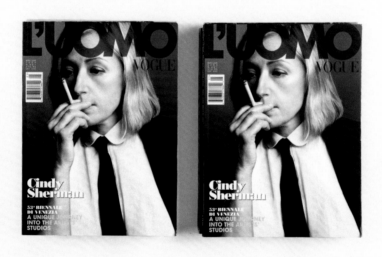

cameras, among other pointed subjects. In the process of investigating the way female subjects are depicted, she seems on some level to be searching for role models, looking for proverbial mother figures. The idiocy of some of Collier's appropriated advertisements is both humorous and instructive. For example, in *Woman with a Camera (Cheryl Tiegs/ Olympus 1)* (2008), the eponymous supermodel holds a camera next to her face, a thoroughly nonfunctional position but one that provides an unobstructed view of her fully made-up and coiffed visage. She is wearing a fashionably modified version of a professional photographer's shooting vest, indicating perhaps that the camera is being marketed to women—except that the image is not about what the person can do with the camera but rather how she will look while doing it. In this and similar photos, we are provoked to think carefully about who is taking the picture and why.

Open Book #2 (Crépuscules) (2009) is a different kind of self-portrait. Graceful, unmanicured hands hold a book open, revealing a full-bleed, double-page spread of a roiling sea glistening in golden twilight. Whether the sun is going down or coming up, it has been captured at the moment when it crosses the horizon.[3] The gutter of the book bisects the image vertically, dividing it between two portrait-orientation pages. Collier often references doubling, such as this instance innate to the printed book; but the doubling also is a metaphor for the idea that the image serves as a double for the artist, and for the viewer. The title of the piece is a quite literal reference to what is pictured while additionally calling to mind expressions such as "My heart is an open book." The allusion suggests not only the process of personal revelation—in a self-portrait, for example—but more generally the treasures that reside between the covers of a book or magazine, or an album sleeve. That the hands are presumably the artist's also speaks to her process, one that is characterized by deep research, by poring over and sifting through printed matter that resonates with her emotionally, intellectually, and artistically. Collier describes her aesthetic as "forensic," partly in reference to the factual precision with which she renders her images. But the process of finding the materials to photograph, to present as evidence, is the work of a detective.[4] The hands that grip the seascape in

3 See "In Between: Tom McDonough in Conversation with Anne Collier," *Fantom Photographic Quarterly*, no. 4 (Summer 2010), pp. 79–80.

4 See "Anne Collier with Bob Nickas," in Jan Verwoert, ed., *Anne Collier*, exh. cat. (North Vancouver: Presentation House Gallery, 2008), p. 12.

Open Book #2 remind the viewer that photographs on paper are things that can be touched and handled, contemplated, and fixed in memory rather than swiped. Collier's hands evoke our personal investment in even the most banal vernacular reproductions.

THE SORROWS OF WERTHER

By Johann Wolfgang von Goethe *

Book I

May 4.

How happy I am that I am gone! My dear friend, what a thing is the heart of man! To leave you, from whom I have been inseparable, whom I love so dearly, and yet to feel happy! I know you will forgive me. Have not other attachments been specially appointed by fate to torment a head like mine? Poor Leonora! and yet I was not to blame.

Moyra Davey

Les Goddesses, 2011

ANNE COLLIER

Anne Collier's photographs offer a straightforward presentation of found images and printed ephemera, and explore themes of appropriation, iconography, and surrogacy. The items pictured—including record albums, cassette tapes, vintage magazines, and posters—are populated by motifs such as the camera, the eye, and the female body. Collier shoots her subjects against a neutral background and often employs the effect of doubling to highlight seemingly identical objects that have been individualized by use and wear. One of the artist's recurrent subjects is the "woman with a camera" trope often found in films and advertisements from the 1970s and '80s. Such images seem to suggest that a woman's use of a camera signals her independence and empowerment since the protagonist takes the mechanism of representation into her own hands. Collier's attention to this pervasive motif casts suspicion on such claims, reminding viewers that possession of the camera has not liberated these women from becoming subjects of the male gaze. Though layered with feminist critiques of mass media, Collier's images of famous women—Judy Garland, Marilyn Monroe, and fellow artist Cindy Sherman, for example—can also be interpreted as oblique self-portraits. The titles of these works often include references to the (always male) photographer of the original image in a self-reflexive gesture that further highlights how women artists—whether singers, actors, or photographers—are represented in a heterosexual economy of desire. Collier was born in 1970 in Los Angeles. She received a BFA from the California Institute of the Arts, Los Angeles, in 1993, and an MFA from the University of California, Los Angeles, in 2001. Collier lives and works in New York.

 — Susan Thompson

SUGGESTED READING

Collier, Anne. *Woman With A Camera (35mm)*. New York: Hassla Books, 2009. With an essay by Tom McDonough.

Darling, Michael. *Anne Collier*. Exh. cat. Chicago: Museum of Contemporary Art Chicago; New York: Artbook/D.A.P., 2014. With essays by Darling, Chrissie Iles, and Kate Zambreno.

"In Between: Tom McDonough in Conversation with Anne Collier." *Fantom Photographic Quarterly*, no. 4 (Summer 2010), pp. 78–87.

Verwoert, Jan, ed. *Anne Collier*. Exh. cat. North Vancouver: Presentation House Gallery, 2008. With an essay by Verwoert and an interview with the artist by Bob Nickas.

PLATES

I
Crying, 2005
Chromogenic print, 99.1×134 cm

II
Woman With a Camera (Cheryl Tiegs/Olympus 1), 2008
Chromogenic print, 80.6×108 cm

III
Open Book #2 (Crépuscules), 2009
Chromogenic print, 112.1×149.9 cm

IV
May/Jun 2009 (Cindy Sherman, Mark Seliger), 2009
Chromogenic print, 102.2×127.3 cm

V
Photography, 2009
Chromogenic print, 144.8×127 cm

At the Palazzo delle Esposizioni, I settle into a couch to watch Moyra Davey's *Les Goddesses* (2011), having seen bits of it at home in New York. Before I arrive at the Palazzo, I walk by chance past the bookshop where Francesca Woodman first showed her photographs; later I will learn that Sarah Charlesworth has died. Rome is haunted by the ghosts who inhabit its ruins, and for me by decades-old memories of visits past. Traveling alone now, I feel multiply dislocated in time and space.

In the first scene of Davey's video, shot in a mirror, the artist turns on the camera and lets it run as she moves around her prewar apartment. She walks into and out of the frame, an audio player in her hands feeding a headphone prompt in her ear.[1] Her narration begins:

> Sit on the floor in sunlight and read through eight small notebooks going back to 1998 looking for a phrase about Goethe: *The stars above, the plants below*. The thought is connected to Goethe's mother and what she taught him about the natural world; more generally it is about how people lived in constant relation to nature.
>
> I never found the reference; it was something I stumbled across on the internet, but it led me to *The Flight to Italy*, Goethe's diary.[2]

Thus Davey commences by rooting herself in text. She reads and recounts the subject of her reading, which parallels Goethe's long-anticipated first trip to Italy at age thirty-seven. She goes on to note his careful observations of his surroundings, and his pleasure in being able to see firsthand the country he had studied all his life through books. Then, shifting to a close-up, Davey struggles to flip the plasticized pages of a tourist booklet of colorized snapshots of Roman ruins with her left hand as her right holds the camera. Returning to traversing her apartment, again visible in the mirror's reflection, she finishes her recitation and turns off the camera. The next shot is the view out her window. It is evening, and two streams of traffic course below

1 The final credits of *Les Goddesses* include the following explanation: "The pre-recorded audio prompt of my narration was inspired by Suzanne Bocanegra's performance *When a Priest Marries a Witch*," first performed in 2010 as "an artist talk by Suzanne Bocanegra starring Paul Lazar," of the Wooster Group. See http://suzannebocanegra.com/work/when-a-priest-marries-a-witch-an-artist-talk-by-suzanne-bocanegra-starring-paul-lazar (accessed October 14, 2014).

2 Quoted from the artist's slightly modified version of the *Les Goddesses* narration published as Moyra Davey, "The Wet and the Dry," in *The Social Life of the Book* (Paris: Paraguay Press, 2011), p. 17.

alongside the current of the Hudson River, one white headlights, the other red taillights.

The second of the twenty-two short video passages that comprise the hour-long work is titled "The Real." In it, Davey and her dog step around boxes and a large portfolio of photos on the floor, presumably in the artist's studio, with a copy stand prominently in the room's center at the foot of a single bed. Davey moves one of the boxes to the bed. In close-up we see its cover: a large gelatin silver photo of a lean young woman, torso nude, staring cheekily at the camera. The label reads "WHAT HAD SEEMED PIETY / PHOTOGRAPHS BY MOYRA DAVEY." The artist opens the box and proceeds to present to the camera individual photos and exhibition announcements, one of which is dated 1984.

The box is filled with studio portraits of the nude young woman (the artist?), who flexes for the camera, her rippling muscles and cropped hair contrasting with her feminine breasts. An exhibition postcard reproduces a photo of four women around the same age, mostly short-haired but one with a shag, recalling the gender-bending album covers and publicity photos for circa-1980 bands like the Clash, Roxy Music, and David Bowie in his glam rock phase.[3] When Davey finishes her monologue, she closes the box. The final shot, once again, is out the window, where it is now snowing.

The rest of the video follows the rhythmic course of the initial segments. Davey sometimes reads her script, at other times listens to it through an earbud while simultaneously reciting what she hears. Close-ups record her hands flipping through her early black-and-white photos, the postcard booklet of Roman ruins, and other books. The moments between sections are often marked by fixed shots out her apartment window, charting the changing seasons and light, that cut to black intertitles, indicating the end of one section and the beginning of the next.

Davey's narration is a first-person account of her reading and note-taking, focusing on diaristic and epistolary writing about transformative journeys that are, like Goethe's, dependent on close observation of daily life, and that are informed by complex personal and familial

3 Davey names these bands, specifically, in her monologue (see ibid., p. 25). These late 1970s/early 1980s British proto-punk and art bands were popular, in part, for their highly artificed styles of self-presentation that ironically comment on gender stereotypes through hypermasculine leather jackets and men's suits often in combination with feminine-coded long hair, eye makeup, and glitter. The young women in Davey's photos take on traditional macho male attire, like sleeveless white T-shirts, sometimes appearing as lookalikes for Bryan Ferry and Joe Strummer, if not David Bowie.

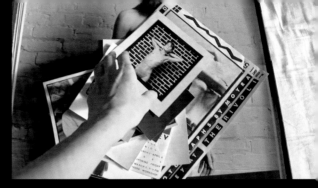

The Wet

BY MARY WOLLSTONECRAFT.

LONDON:
PRINTED FOR J. JOHNSON, ST. PAUL'S CHURCH-YARD

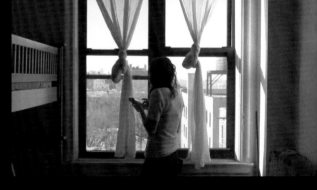

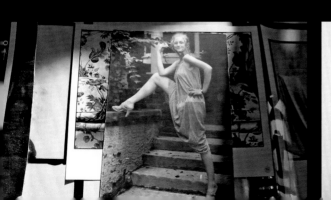

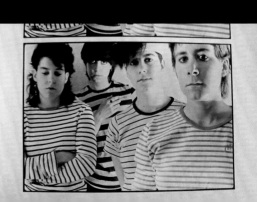

Most people will divulge
more than you want
to know.

People often want to
recite the tragic events
that have deformed
their lives.

Offering up their pasts
as a series of tableaus
of deceptions,

or unspeakable insults.

What is said is often
unremarkable.

though sometimes
horrible,

but it's still easy to feel
the timrousness of
another's life,

as well as your own.

since people blame
others endlessly.

and these assaults
and imprecations
clutter.

like a dog's defecations
on the street.

their lives and stories.

since interest in other
people is also an
interest in yourself.

because human beings
are interested in
themselves and in
ways of survival.

All stories are somehow
survival stories.

with bad or good
fortunes.

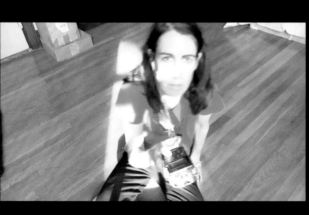
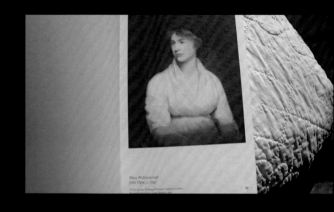
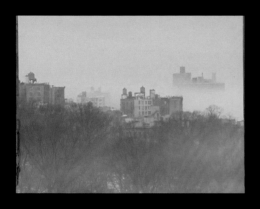
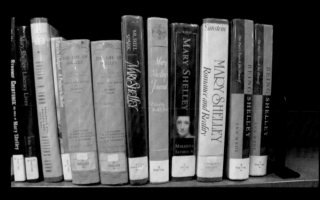

Fanny

circumstances, which she compares to her own. The title *Les Goddesses* refers to the nickname given to novelist and early feminist Mary Wollstonecraft's daughters, Mary, Fanny, and Claire Clairmont.[4] Davey describes their complicated relationships with poets Shelley and Byron as they traveled through Europe, including residence in Italy, equating the journeys to her own trips to Paris and her and her sisters' experiences growing up in Canada two hundred years later: "It was a different time and different kind of rebellion, nonetheless many thought of us as a female force—goddesses no; but 'Amazonian,' yes—to be reckoned with."[5] Davey's video collapses the past into the present as the artist brings (back) to life the writing of Wollstonecraft et al. and her own early photographic portraits in the context of her present-day studio-home. In only one scene do we hear voiceover narration, in which she recounts a visit to a homeopathic doctor for treatment of multiple sclerosis as she picks up small stacks of books, blowing dust off them and out the open window. The gesture becomes an allegory for the way that images are inscribed with meaning through the juxtaposition of text, as well as how interpretation (here reading) is colored by individual experience.[6]

As she weaves narrative strands together, Davey aligns writing and reading as intimate experiences through which the producer-speaker and the reader-receiver share a vivid coterminous temporality typically associated with photography.[7] In *Les Goddesses*, she is a sort of Scheherazade extending the life of the works she appropriates, both her own and others, through reading, recounting, reviewing, representing, and reciting. The books and photographs live, as does she, as long as she keeps telling the story. The collapsing of her narrative and the

4 Ibid., p. 23, citing Aaron Burr.

5 Ibid., p. 25. Significantly, Wollstonecraft died of postpartum infection, and Davey's father from a fall, thus both the late eighteenth- and late twentieth-century "goddesses" experienced the tragic loss of a parent.

6 Among the visible titles are *The Writer and Her Work*, books by or about Sylvia Plath and Anne Sexton, and Mary Kelly's *Post-Partum Document*. This is the only scene in which Davey is bespectacled.

7 For Roland Barthes's notion of the future perfect of photography, see his *Camera Lucida: Reflections on Photography* (New York: Hill and Wang, 1981). Though Davey doesn't specifically mention Barthes in *Les Goddesses*, she has referred to his work often in other texts, including especially Davey, *The Problem of Reading* (Los Angeles: Documents, 2003) and "Notes on Photography & Accident," in Davey, *Long Life Cool White: Photographs & Essays by Moyra Davey*, exh. cat. (Cambridge, Mass.: Harvard University Art Museums; New Haven, Conn.: Yale University Press, 2008), pp. 79–119. See also Adam Szymczyk, ed., *Moyra Davey: Speaker Receiver*, exh. cat. (Basel: Kunsthalle Basel; Berlin: Sternberg Press, 2010).

Wollstonecrafts' models the way Davey's story combines with that of the viewer of her work: her story is mine, or speaks for me.

Davey presents her reading, her research, as a quest for guidance and inspiration in the work of writers and artists she admires. In *Les Goddesses* she also looks to filmmakers Louis Malle and Jean-Luc Godard as she elaborates the distinctions between the Wet and the Dry, as she puts it—between reality and self-revelation captured through direct observation with a vérité aesthetic versus the controlled creative space of the studio and the self-reflexive processes of reading and note taking. Literally and figuratively, the snow outside her window is wet; the dust on her books is dry. *Les Goddesses* embodies the two approaches: it is shot in low-tech fashion, with available light, on location in the artist's home-studio, and reveals the means of production (the camera visible in the mirror, the artist manually turning it and her audio player off and on, the recorded voice audible from her earpiece as she stumbles to replicate the words she hears). While this suggests the ethos of Nouvelle Vague documentary, Davey repeatedly returns to Malle's complicating thoughts about the real:

> He lives in his head, sometimes thinking of the past, but mostly caught up in a work whose meaning will only be locked in at a future moment. To every new situation his first instinct is to invoke memory and analysis: a scene on a beach at daybreak reminds him of one twenty years earlier when he was making his first film. "A tamer of time, a slave of time" is how Malle understands his predicament. At a certain point he and his crew will stop filming. Only then will they begin to experience the present tense, the slowness of time, and what Malle calls "the real."[8]

This experience of the real is what Davey seeks and finds in Goethe's, Wollstonecraft's, and the Shelley crew's travel writing, their careful attention to their surroundings, and her own written and photographed observations of people and nature. It is this promise of photography— that it can communicate something profound about life by carefully attending to the mundane details of daily existence—that Davey espouses as she ends the video, with a description of rising in the morning to catch the light gleaming off a building out her Upper West Side window.

8 Davey, "The Wet and the Dry," p. 18.

Moyra Davey's work initially featured documentary photographs of her family and friends, and later came to focus on the quiet, overlooked details of daily life. In 2009, while on a residency in Paris, she folded one of her photographs and mailed it to her New York gallery for inclusion in a group show as a way to circumvent the logistics of transport. This gesture became the basis for her "mailer" works, in which photographic prints are folded up, taped at the edges, stamped, addressed, and put in the mail, accumulating on their surfaces the attendant marks of their travel through the postal system. The sixteen photographs that comprise the mailer work *Trust Me* (2011) were sent to writer Lynne Tillman, each image pasted with a fragment of text from Tillman's book *American Genius, A Comedy* (2006). Depicting outsize close-ups of the fronts of worn pennies, Davey's *Copperhead* series (1990) also emphasizes the circulation of banal everyday objects individuated by the accumulation of human touch. In the mid-2000s, the moving image took on a renewed prominence in Davey's work. Inspired by her deep interest in the process of reading and writing, Davey's essay-istic video practice layers personal narrative with detailed explorations of the texts and lives of authors and thinkers she admires, such as Walter Benjamin, Jean Genet, and Mary Wollstonecraft. Davey's own writing is central to her videos. The transcript of *Fifty Minutes* (2006), in which Davey reflects on her years in psychoanalysis, was published as a personal essay in the artist book *Long Life Cool White: Photographs & Essays by Moyra Davey* (2008), a symbiotic practice the artist continues. Her text "The Wet and the Dry" formed the basis of the narration of *Les Goddesses* (2011). Born in 1958 in Toronto, Davey received a BFA in fine art from Concordia University, Montreal, Quebec, in 1982, an MFA in fine art from the University of California, San Diego, in 1988, and attended the Whitney Museum of American Art Independent Study Program in 1989. Davey lives and works in New York.
— Susan Thompson

Davey, Moyra. *Long Life Cool White: Photographs & Essays by Moyra Davey*. Exh. cat. Cambridge, Mass.: Harvard University Art Museums; New Haven, Conn.: Yale University Press, 2008. With introduction by Helen Molesworth.

——. *The Problem of Reading*. Los Angeles: Documents, 2003.

Jigarjian, Michi, and Libby Pratt, eds. *Writing as Practice: Peripheral Continuity*. New York: Secretary Press, 2012. With texts by Nayland Blake, Jigarjian and Pratt, and Lynne Tillman, and conversations between Moyra Davey and Zoe Leonard, Andrea Geyer and Carlos Motta, and Ethan Swan and Anny Turyn.

Latimer, Quinn. "Woman of Letters." *Frieze*, no. 147 (May 2012), pp. 186–93.

Moyra Davey: Burn the Diaries. Exh. cat. Brooklyn: Dancing Foxes Press, 2014. With essays by Moyra Davey and Alison Strayer. Accompanied by *Moyra Davey: Burn the Diaries [a supplement]*. Exh. brochure. With an essay by Ingrid Schaffner and an interview with the artist by Matthias Michalka.

Szymczyk, Adam, ed. *Moyra Davey: Speaker Receiver*. Exh. cat. Basel: Kunsthalle Basel; Berlin: Sternberg Press, 2010. With essays by George Baker, Moyra Davey, Bill Horrigan, Chris Kraus, Eric Rosenberg, and an interview with the artist by Szymczyk.

PLATES

I, II, IV, V
Les Goddesses, 2011
HD color video, with sound, 61 min.

III
Trust Me, 2011
Sixteen chromogenic prints, tape, postage, and ink, 44.5 × 30.5 cm each

Leslie Hewitt

Riffs on Real Time,
2006–09

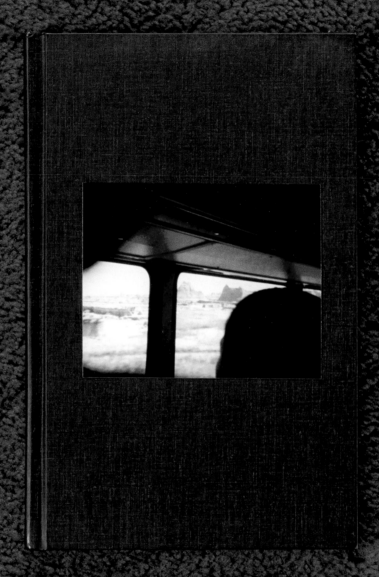

Leslie Hewitt's *Riffs on Real Time* (2006–09) is a series of ten deeply saturated color photographs. Each captures printed matter, including books, magazines, snapshots, and documents, placed one atop the other on the floor. The image, a rhapsody of frames within frames, assumes a kind of tripartite pyramid structure: the floor framed by cropping (and, subsequently, an actual wooden frame) provides a ground for a rectangular publication or sheet that in turn becomes a support and frame for a snapshot that rests on top of it. The clear focus and lighting of each photograph carefully renders creases in paper, brittle yellowed pages, and shadows caused by a fold or curling edge. Such detail elicits a desire to touch, to feel the texture of the carpeted floor or to turn down a corner to reveal what is hidden. When the photograph, shot from overhead, is transposed to the wall, the materiality of the objects, with their convincing shadows and their slight increase in scale (somewhat but not obviously larger than life), combine to create an intriguing perceptual uncertainty.

The overall impression of a room full of Hewitt's photographs is one of syncopated blocks of color, of harmony, melody, and dissonance. The tight organizational system of *Riffs on Real Time* creates opportunities for variations within the set on several themes, as the title's reference to the disciplined structure of improvisation suggests; the interior spaces, images, and objects Hewitt uses vibrate within each photo and create rhythms that register across the series. In some ways, the work also resembles structured verse. The individual photo, like a sonnet, takes a prescribed form that each poet works within (and against), linking images that operate on multiple levels. The overall series, then, is akin to a cycle.

Riffs on Real Time (1 of 10) opens the series with a view of a deep blue hardcover that almost disappears into its celestial ground, a pile carpet of equal hue. The book is surmounted by a snapshot that shows an obscured landscape through the windows of a moving bus, with a shadowed figure in the extreme foreground looking out at rocky outcroppings in the distance. The image functions like an aperture into depthless space, a porthole view from a submarine or from an airplane into an expansive sky. The enigmatic Everyman elicits questions: Who is this person? Where is he going? The odd angle, off-centered cropping, and blurred focus—characteristics this snapshot shares with virtually all others in the series—call attention to the perspective of the photographer who took it. This enigma raises yet another, perhaps more significant, question: who took this picture and why?

Several found photos featured in the series show people congregating in suburban settings, on manicured lawns enclosed within hedged yards, for example, in *RoRT (2 of 10)*, *RoRT (4 of 10)*, and *RoRT (7 of 10)*; others document intimate groups socializing in interior spaces, such as in *RoRT (3 of 10)*, *RoRT (6 of 10)*, and *RoRT (9 of 10)*. These snapshots appear to have been taken by a friend or family member of the people depicted. The clothing, hairstyles, and details of each environment suggest the private worlds of middle-class Americans of African descent. The tonality of the photos and their edges—white-bordered or borderless with rounded corners—point to the 1970s, and earlier, and in fact one print is date-stamped "June 1972."

Repeatedly the printed-matter substrate on which the snapshot rests presents a mass-produced image of a public space or landscape. In *RoRT (3 of 10)*, a small color picture that captures a conversation at a formal gathering lies atop a page of black-and-white reproductions from *Ebony* magazine of students in an anatomy class taught at a historically black college; *RoRT (7 of 10)* presents a backyard cookout in relation to *Ebony* reportage of the Soweto student demonstrations in South Africa.[1] The black-and-white snapshot in *RoRT (9 of 10)* shows airline passengers relaxing, apparently midflight, and floats within the frame of a book page's vivid color image of a graffiti-covered subway train on an elevated track as a city bus picks up passengers below.[2] These juxtapositions create situations in which mundane groupings of people are inserted into the middle of radically different environments, be it national, via the post–civil rights era landscape of the United States;

I thank Leslie Hewitt for her careful attention to this text, and for encouraging me to resist deterministic readings of her work.

1 Alex Poinsett, "Mehany Medical College Celebrates Its 100th Anniversary," *Ebony* (October 1976), p. 33; and "Ebony Photo-Editorial: The Handwriting on the Wall," ibid., p. 157. John H. Johnson started publishing *Ebony* magazine in 1945. Modeled on *Life*, *Ebony* is dedicated to asserting the visibility of black professionals and issues important to African Americans, along with ads directed to this audience. The *Ebony* archive is now available online: http://www.ebony.com/archives#axzz3GWN-mLD6X (accessed August 15, 2014).

2 The South Bronx image is from Henry Chalfant and Martha Cooper, *Subway Art* (New York: Henry Holt, 1984), p. 13. While it is not always necessary to know the publications with which Hewitt creates her compositions, she includes enough information to allow them to be identified relatively easily, especially in the age of the Internet (though I sense a distinct advantage on my part, having come of age during the period depicted). The format of *Riffs on Real Time*, with its strata of information, suggests geological sedimentation and thus invites a kind of investigative digging, an archaeological research into its images. Nevertheless, like a family album, the images will be read differently by the viewer who is familiar with the sources. See Deborah Willis, ed., *Picturing Us: African American Identity in Photography* (New York: New Press, 1994).

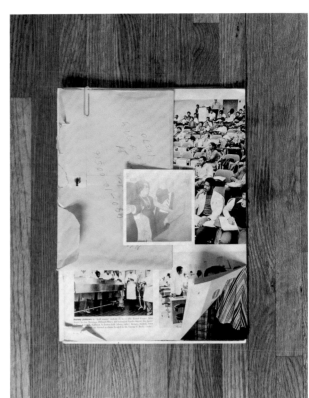

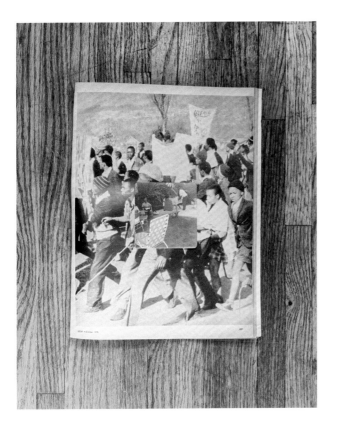

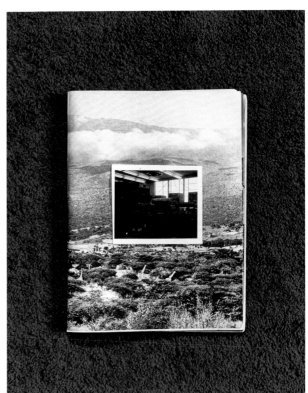

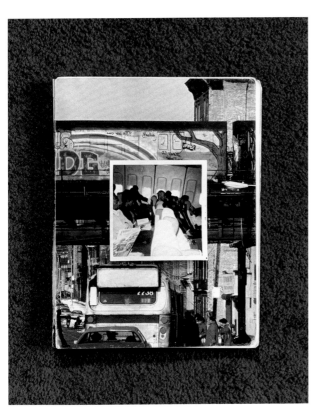

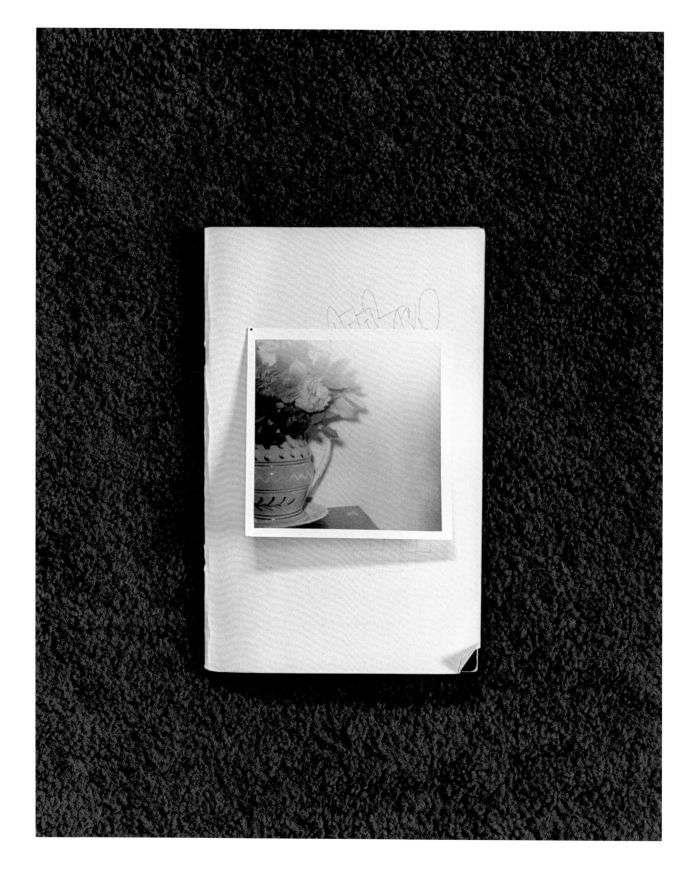

the international setting of the student protests in South Africa; or the graffiti-filled cityscape of the South Bronx defined by the rebellious creativity of black, Latino, and immigrant communities. Taken together, these combinations render the public and private spaces African Americans inhabited in the 1970s and early '80s. They speak in multivalent voices of the visual representation of physical containment and exclusion within the realm of the public sphere, as well as of the invisibility of the private.

Concomitantly, they propose a real time reverie on the existential condition, and a lyrical riff on black memory.[3] Some pictures include romanticized versions of sublime landscapes, such as *RoRT (4 of 10)*, a dramatic depiction of Victoria Falls arced by a rainbow, and *RoRT (8 of 10)*, which features a richly textured black-and-white view of the Serengeti Plains. The latter magazine reproduction is surmounted by a snapshot of a circa 1960-era computer lab, the former by a small, evocative black-and-white print of a hedged yard, empty save for the solitary man at the right edge of the picture's border, who points his camera outside the yard (and the frame). Like the bus rider in the first image in the series, he is a man enclosed, looking out onto the world. *Riffs on Real Time* presents varieties of spaces this person might see or inhabit, including mythic ones that haunt the imagination. The juxtaposition of the man with a camera and a picture of a famed African destination—notably devoid of human beings—emphasizes the distance from, and perhaps a yearning for, an ideal expansiveness that can seem impossibly remote in time and space, a figure of collective as well as individual fantasy, hinted at by the way that the graffiti on the South Bronx subway train harkens the rainbow over Victoria Falls.

The massive mainframes in the snapshot of the computer lab in *RoRT (8 of 10)* and the sheet of archaic code that appears in *RoRT (2 of 10)*, both outmoded, allude in a different way to the realm of memory. Today the transformative role of computers in storing memory—our personal recollections, in the form of digital images—is taken for granted. Hewitt's photographs evoke moments in time through the objects' literal and figurative dating (time stamps, wear and tear on publications and photographs) and their display of color palettes associated with the past. At the same time, by emphasizing our physical engagement through

3 See Huey Copeland, "Leslie Hewitt," *Artforum* 48, no. 6 (February 2010), pp. 184–87.

the physical materialization of pristine, highly realistic images, Hewitt heightens our awareness of the split temporality of photography as not only an intellectual and emotional experience but also an embodied one.

Riffs on Real Time (10 of 10) is the last photo in the series, the last page, the last stop on this journey. A beautiful and strange black-and-white snapshot of a vase of flowers cropped vertically in half echoes the right half of the inside back cover of the book underneath it, with the hint of its blue front cover revealed by an upturned corner as a kind of coda.[4] This still life obscures the lower half of a graffiti sketch under its top edge and a geometric doodle along the bottom, seeming reverberations of the graffiti drawing in *RoRT (6 of 10)* and the patchwork quilt reproduced on the back cover of the book in *RoRT (5 of 10)*.[5] Like Hewitt's photographs, the geometric interplay of the quilt and the exuberant line of the graffiti are returning again to the internal structure of improvisational gestures, all riffs in real time, two-dimensional expressions that are materialized into three and open a metaphorical window into the fourth.

4 The flare in the upper right corner of the snapshot suggests a reflection from the surface of the photo; in other words, it provides evidence that this might be a photo of a photo, raising questions about the genesis of the snapshots in the series. Hewitt has said that the photos were borrowed from friends and acquaintances and returned to their owners (Leslie Hewitt, interview by Jeffrey Warda, Solomon R. Guggenheim Museum Off-Site Storage, New York, June 29, 2011). Likewise, she photographs rugs in the homes of acquaintances. Thus her process emanates from the private space of a community rather than that of an individual.

5 The reproduction of the quilt wraps the cover of Eli Leon, *Who'd a Thought It: Improvisation in African-American Quilt-making*, exh. cat. (San Francisco: San Francisco Craft and Folk Museum, 1987). The caption on the copyright page reads: "*Framed Improvisational Block* (detail). Pieced by Rosie Lee Tompkins, Richmond, California, 1985. Quilted by Willia Ette Graham, Oakland, California, 1985."

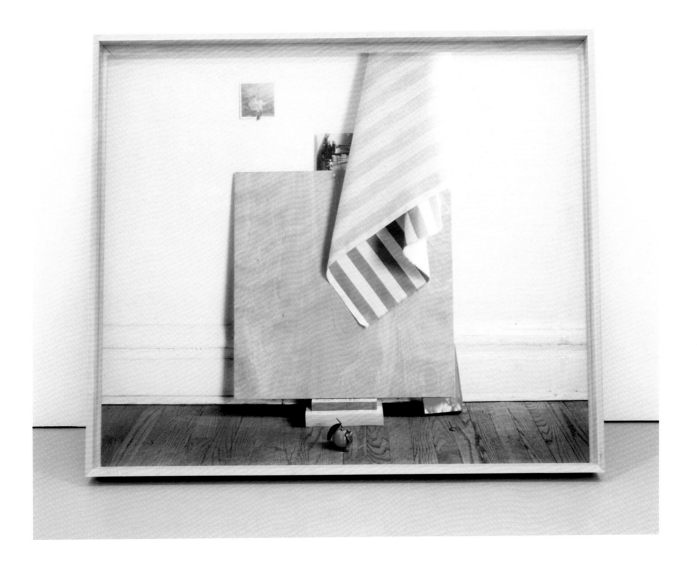

Commingling photography and sculpture, Leslie Hewitt's works present arrangements of personally and politically charged materials—including historically significant books and magazines from the 1960s and '70s as well as family photos (not necessarily her own)—that conjure associative meaning through juxtaposition. In Hewitt's *Riffs on Real Time* (2006–09), snapshots lay atop appropriated printed matter shot against a wood floor or carpet so that the contrasting textures of these layered materials build up and outward toward the viewer. In Hewitt's photo-sculptural series, the photographs begin to inhabit the space of the viewer. Positioned on the floor, their frames lean against the gallery walls, asserting their materiality. The images in the series *Midday* (2009) feature remixed arrangements of a set vocabulary of references: a wood plank, a mandarin orange, a swath of blue-and-white striped fabric, a copy of Claude Brown's *Manchild in the Promised Land* (1965)—the autobiographical coming-of-age story of a young man in 1950s Harlem—and various snapshots of Harlem interiors and outdoor shots of Haarlem and Rotterdam in the Netherlands. These elements are themselves pictured on the floor leaning against a wall—stacked, balanced, and perched atop one another in various combinations—and photographed frontally in a visual presentation that suggests a collapse of both space and time. Hewitt's references to the seventeenth-century Dutch still life tradition present a postcolonial critique of the economic infrastructure predicated on the movement of labor, food, and material objects in early capitalism that produced the genre. Installations of Hewitt's works often include architecturally scaled sculptural interventions that call attention to the viewer's physical experience of the gallery space. Born in 1977 in Saint Albans, New York, Hewitt earned a BFA from the Cooper Union for the Advancement of Science and Art, New York, in 2000, and an MFA in sculpture from Yale University, New Haven, Connecticut, in 2004. She was also a Clark Fellow in Africana studies and cultural studies at New York University from 2001 to 2003. Hewitt lives and works in New York.
— Susan Thompson

SUGGESTED READING

Adusei-Poku, Nana. "As If Time Could Talk," in *Not Now! Now! Chronopolitics, Art & Research*, edited by Renate Lorenz. Vienna: Academy of Fine Arts Vienna; Berlin: Sternberg Press, 2014, pp. 26–48.

Copeland, Huey. "Leslie Hewitt." *Artforum* 48, no. 6 (Feb. 2010), pp. 184–87.

Fassi, Luigi. "Construction of Memory." *Mousse*, no. 21 (Nov./Dec. 2009), pp. 87–90.

Hopkins, Randi. *Momentum Series 15: Leslie Hewitt*. Exh. brochure. Boston: Institute of Contemporary Art, Boston, 2011.

Lax, Thomas J. "Toward an Ethics of Double Entendre," in *New Intuitions: Artists in Residence 2007–08*, edited by Naomi Beckwith. Exh. cat. New York: Studio Museum in Harlem, 2008.

Leslie Hewitt: Sudden Glare of the Sun. Exh. cat. St. Louis: Contemporary Art Museum St. Louis, 2013. With essays by Johanna Burton, Dominic Molon, and Esperanza Rosales.

"November 2008/Panel Discussion: Why Photography Now? Harrell Fletcher, Leslie Hewitt, A.L. Steiner," in *Words Without Pictures*, edited by Charlotte Cotton and Alex Klein. New York: Aperture, 2010, pp. 398–414.

PLATES

I–X
Riffs on Real Time, 2006–09
Ten chromogenic prints, eight 76.2 × 61 cm each; two 61 × 76.2 cm each

Riffs on Real Time (1 of 10)
Riffs on Real Time (2 of 10)
Riffs on Real Time (3 of 10)
Riffs on Real Time (4 of 10)
Riffs on Real Time (5 of 10)
Riffs on Real Time (6 of 10)
Riffs on Real Time (7 of 10)
Riffs on Real Time (8 of 10)
Riffs on Real Time (9 of 10)
Riffs on Real Time (10 of 10)

XI
Untitled (Seems to Be Necessary)
(from the series *Midday*), 2009
Chromogenic print in custom maple frame, 133.4 × 158.8 × 12.7 cm

Elad Lassry

Four Eggs, 2012

Bengal, 2011

Men (055, 065), 2012

*Untitled
(Woman, Blond)*, 2013

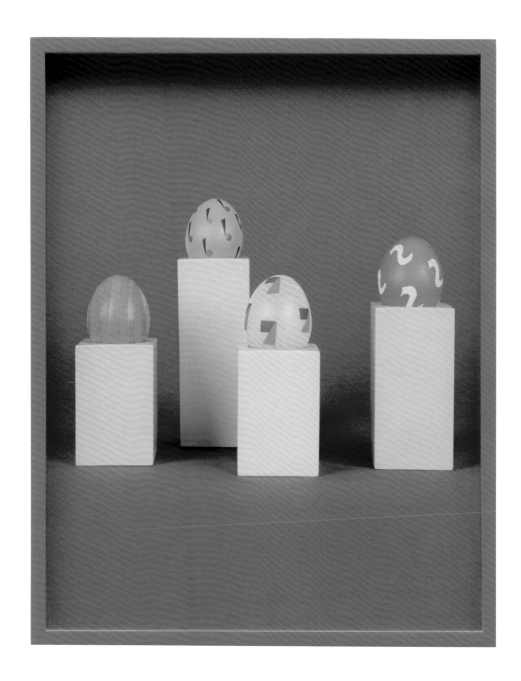

Installations of Elad Lassry's pictures are spare and rigorously symmetrical, situated on parallel planes across the space, equidistant from angled walls. In the gallery, his small photo-objects read like foreign stamps obediently affixed to the corner of a large white envelope: first an American notices the burst of color and then, regarding the strange subject of the stamp, she wonders, Why does every other country have more distinctive postage?[1] Lassry's *Four Eggs* (2012) is a classic example: its deep fuchsia frame matches the background of the image it houses, creating the effect of a brightly colored unitary object among equally saturated and gaudy others. On closer inspection, the eponymous four eggs confound. They appear to be Easter eggs, but three are painted with incongruous free-floating abstract geometric motifs, and one seems decorated for Christmas.[2] All are displayed on modernistic plinths, as if to assert their value, their revered status. In *Four Eggs*, Lassry exploits the technical conventions of advertisements: iconic centrality; consistent, almost shadowless lighting; hyperclarity of focus; and a monochromatic environment to minimize distraction. The horizontal and vertical surfaces of the stagelike setting are one continuous hue, yielding an uncanny sense of a gravity-free and timeless space.

Four Eggs is one of many similar Lassry still lifes of tchotchkes and foodstuffs, from china and glass figurines to gourds and cucumbers, as well as more obscure objects of even obscurer desires. *Bengal* (2011), a portrait of an exotic breed of house cat, is so exquisitely rendered as to raise the question of whether it is taxidermy. (Given that the artist lives in Los Angeles, the home of the Dream Factory, where animal handlers train pets for their fifteen minutes of fame, it is most likely alive.) While the cat is winningly perfect with its tail curled neatly around its front paws, the most riveting element of the picture

1 This observation is no longer true of U.S. stamps, as digital production allows customization, though it remains true of American currency.

2 It is tempting to think of this oddball as a photography in-joke about the difficulty of accurately reproducing green and red together. But what value is there for accuracy, and thus truth to reality, in such a picture as this? Lassry has cautioned that he is uninterested in symbolism, and by selecting and abstracting—by making generic—such overdetermined objects as Easter eggs, he seems to equalize and thus negate any reading outside his exacting system. Yet it is impossible to ignore the symbolic potential of embellished (i.e., decorated) eggs, their metaphor of transformation (from bird egg to egg art) related to the Christian idea of transubstantiation (and the artistic conception of the Readymade). Further, these eggs are hidden and sought after, just as the viewer seeks meaning.

is its bright green eyes, accentuated by the contrasting deep orange background.

A tension develops in Lassry's pictures between intensely stylized presentation and equally intense realism. While he uses postproduction digital techniques, his work is essentially film-based, both formally and conceptually. By carefully rendering his subjects before the lens exactly as they appear, he harnesses the truth quotient of documentary photography; and yet his stagecraft, powerfully conveyed in the impossible perfection of his subjects, points to artifice and the world of fantasy. In Lassry's hands, too-perfect humans appear to be automatons. In *Men (055, 065)* (2012), for example, two young people look at us, two sets of eyes mirroring our gaze just as their bodies mirror each other. The men share an upright bearing, dark hair, and identical outfits with almost perfectly registered buttons. The monochromatic black-and-white palette of the photo, like its simple title with parenthetical enumeration, also equalizes their differences, especially their eyes, which uniformly reflect two lightboxes each, amplifying the sense that they are doubles.

In scale and tonality, *Men (055, 065)* is characteristic of the photographic genre of the headshot, the calling card of actors represented as products for the consumption of casting directors. With gelatin silver photos like this one, Lassry typically uses natural walnut frames, a nod to the mid-twentieth-century notion that black-and-white is more true to reality than the garish processes of early color film. Today, however, in a world where digital color predominates, black-and-white seems artificial, just one of many vintage choices provided by filter apps. Lassry's use of it for portraits renders the figures marmoreal, heightening the uncanny effect native to all photographs, which rests on the knowledge that what is pictured, though immortalized in the photograph, may no longer exist. In this way, the "twins" are ghosts, specters of a time past. *Men (055, 065)* also serves as performance documentation: the two men are dancers, a fact that might be deduced from their posture, physiques, and matching costumes.[3] Lassry captures the uncanniness embodied in performance, which always reverberates with

3 They performed in Lassry's *Untitled (Presence)* (2012), which debuted at the Kitchen in New York. On the issue of reenactment in Lassry's work, see Tim Griffin, "Coming to Life," in *Elad Lassry: 2000 Words*, ed. Karen Marta and Massimiliano Gioni (Athens: DESTE Foundation for Contemporary Art, 2013), pp. 7–19. See also Douglas Crimp, "Being Framed: Douglas Crimp on Elad Lassry at the Kitchen," *Artforum* 51, no. 5 (January 2013), pp. 55–56.

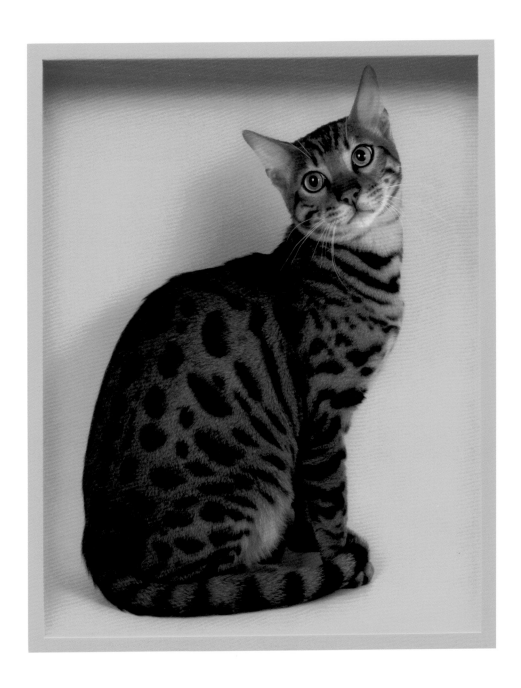

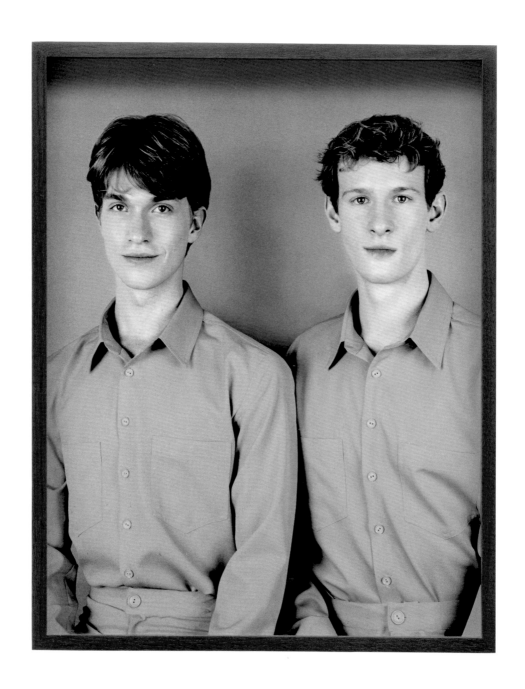

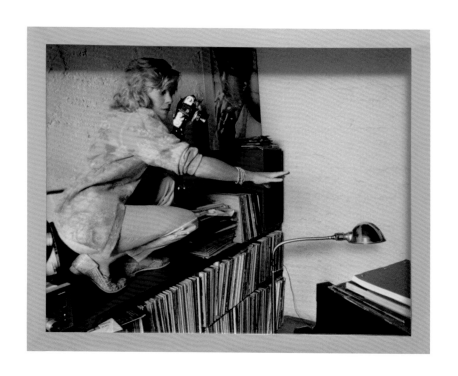

V, VI

questions regarding spontaneity and truth or sincerity versus practice, repetition, and predetermination.[4]

The appropriation-based *Untitled (Woman, Blond)* (2013) presents a sort of performance as well. Only the lower half of the photo is visible, where mannish Caucasian hands massage a white female back. Pleated blue silk wraps the upper half of the frame, denying the viewer that portion of the image and accentuating the play of revealed and clothed bodies: the naked woman is covered from the waist down, while the standing masseur's khaki pants echo the flayed legs depicted in the anatomical drawing behind him. That figure seems to be a kind of zombie, with one leg perched on an odd stone platform and a tightened fist, as if someone who has been skinned could be posing. Conversely, it suggests a fantastic mode of vision offering a view of muscles beneath or through the skin. What the viewer can see in this picture is tantalizing, but what cannot be seen becomes its subject. Lassry's pictures are haunted by the photographic genres and modernist techniques he references, and in the case of *Untitled (Woman, Blond)*, by the unknown assignment that generated the illustration he has used. The picture's silk sheath elicits the urge to gently peel back that layer, like the skin of the anatomical model, and peer beneath at what lies concealed.

Lassry's pictures are riveting in the way that they channel attention to what cannot be seen, and to things that seem to be inconsequential, their significance initially unclear. And yet whether his photographs are staged or found, their subjects are profoundly meaningful, not meaningless. A picture of a cat is, in itself, just one more example of a photographic meme; but *Bengal*, in the company of Lassry's other portraits of cats and cat figurines, within an oeuvre filled with representations of animals, suggests something more. As an archive, his works together begin to tell a story of objects linked in metaphorical chains, the product of "the poetic imagination."[5] One such concatenation ties recurring

4 This tension between reality and fantasy lies at the heart of Freud's definition of the uncanny as something *unheimlich*, both homey and not, familiar and yet vaguely and disturbingly strange. Other examples Freud cites are twins, ghosts, and dolls, all doubles or replicants. In his essay "The 'Uncanny'" ("Das Unheimliche," 1919), in *The Standard Edition of the Complete Psychological Works of Sigmund Freud*, trans. J. Strachey, vol. 17 (London: Hogarth Press, 1955), pp. 218–52, Freud discusses a story about an automaton, a doll, which is mistaken for a living being. (Freud is also concerned with the threat of blindness embodied in dreams, which he ultimately links to castration anxiety.)

5 Roland Barthes, "The Metaphor of the Eye" (1963), in Barthes, *Critical Essays*, trans. Richard Howard (Evanston, Ill.: Northwestern University Press, 1972), p. 240.

representations of eggs, eyes, and other "globular" forms, from the decorated ones of *Four Eggs* to glass and wooden versions, through the searing gaze of eyeballs in portraits of animals and humans, to endearing still lifes of tomatoes, cherries, and onions.[6] These associative chains in the artist's work suggest an erotics that resides in form as well as content.

The luscious sensuality of Lassry's pictures speaks to the artist's specific desires: no matter how curious or banal his subjects, it is clear that he has a sincere fondness for them. The things he lovingly portrays—glistening vegetables, cherished pets, film stills of Anthony Perkins—are objects whose value feels unique to a particular sensibility. Whether or not we share these tastes, we are drawn to the compatible portrait of a desiring subject.

6 It is productive to read Lassry's work through Barthes's analysis of Georges Bataille's *Story of the Eye* (1928) in "The Metaphor of the Eye," in ibid. Barthes analyzes Bataille's pornographic novel in terms of the poetic erotics demonstrated by the "round phallism" of its metaphoric chain of egg—eye—testicle. Rosalind E. Krauss discusses Bataille's story (and the Freudian uncanny) in her important essay on Surrealist photography, "Corpus Delicti," in Krauss, *L'Amour fou: Photography and Surrealism*, exh. cat. (Washington, D.C.: Corcoran Gallery of Art; New York: Abbeville Press, 1985), pp. 55–100. See also the interpretive chain manifested in E. C. Large, "On watching an onion" (1930), repr. in *Elad Lassry* (New York: Luhring Augustine, 2011),

pp. 52–53; and *On Onions*, photographs by Lassry, text by Angie Keefer (New York: Primary Information, 2012). It is interesting to think of Lassry's metaphorical chain(s) in relation to Krauss's interpretation of Giacometti's sculptures, which she reads through Bataille, specifically Giacometti's *Suspended Ball* (1930). See Krauss, "No More Play," in her *The Originality of the Avant-Garde and Other Modernist Myths* (Cambridge, Mass.: MIT Press, 1985), p. 63: "This round phallicism, this collapse of distinction between what is properly masculine and what is properly feminine, this obliteration of difference, is for logic what the perversions are for eroticism: it is transgressive."

ELAD LASSRY

Elad Lassry positions his photographic works as "pictures," entities that operate simultaneously as both objects and images. He presents the photographs in lacquered frames that match the colors of his bright, saturated images, or in warm walnut frames in the case of his work in black and white. Referencing the language of advertising and stock photography—and the attendant notions of desire therein—Lassry's pictures derive from his own studio-based photographs as well as appropriated imagery. Lassry riffs on visual genres associated with the image culture of Hollywood, such as head shots and production stills, and draws frequently on an archive of photos of the American actor Anthony Perkins. He employs techniques such as double-exposure, blurring, superimposition, and collage that create an unsettling instability in each image. Lassry's films, initially focusing on ballet dancers and the subject of a 2009 exhibition at the Whitney Museum of American Art, explore issues of subjectivity and perception, collapsing figure and ground in a flattening of pictorial space. Through the repetition of various thematics throughout his oeuvre, Lassry's individual subjects seem not only to represent themselves, but serve also as generic examples of standard genres, such as portrait, still life, animal, or product photography. More recently, Lassry has begun to incorporate sculptural elements into his pictures, further asserting their materiality by wrapping the frames in a silk valence or penetrating the images with looping colored wires. Lassry was born in Tel Aviv in 1977. He earned a BFA in art and film/video from the California Institute of the Arts, Los Angeles, in 2003, and an MFA from the University of Southern California, Los Angeles, in 2007. Lassry lives and works in Los Angeles.
— Susan Thompson

SUGGESTED READING

Crimp, Douglas. "Being Framed: Douglas Crimp on Elad Lassry at the Kitchen." *Artforum* 51, no. 5 (Jan. 2013), pp. 55–56.

Elad Lassry. Exh. cat. London: White Cube, 2011. With an essay by Douglas Crimp.

Elad Lassry. Exh. cat. Tokyo: Rat Hole Gallery, 2012. With an essay by Akira Mizatu Lippit.

Godfrey, Mark. "On Display." *Frieze*, no. 143 (Nov./Dec. 2011), pp. 90–95.

Ruf, Beatrix, ed. *Elad Lassry*. Exh. cat. Zurich: JRP/Ringier, 2010. With essays by Bettina Funcke, Liz Kotz, Fionn Meade, and Ruf.

PLATES

I
Four Eggs, 2012
Chromogenic print in painted frame,
36.8 × 29.2 × 3.8 cm

II
Bengal, 2011
Chromogenic print in painted frame,
36.8 × 29.2 × 3.8 cm

III
Men (055, 065), 2012
Gelatin silver print in walnut frame,
36.8 × 29.2 × 3.8 cm

IV
Heirloom Tomatoes, 2010
Chromogenic print in painted frame,
36.8 × 29.2 × 3.8 cm

V
Woman (Camera), 2010
Chromogenic print in brass frame,
21.6 × 26.7 × 3.8 cm

VI
Portrait 1 (Silver), 2009
Gelatin silver print with applied silver foil in aluminum frame, 26 × 21 × 3.8 cm

VII
Untitled (Woman, Blond), 2013
Chromogenic print in walnut frame with four-ply silk,
36.8 × 29.2 × 3.8 cm

Lisa Oppenheim

*The Sun is Always
Setting Somewhere Else,*
2006

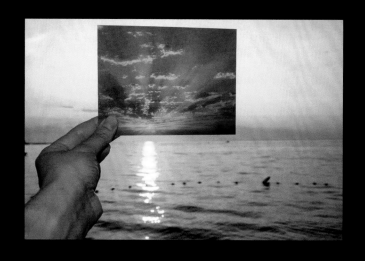

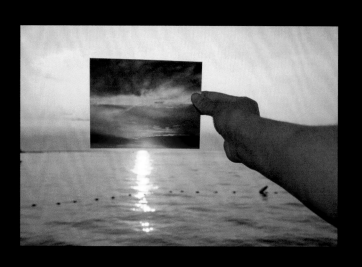

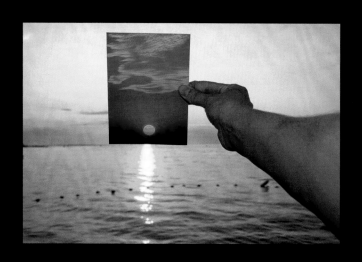

A Kodak Ektagraphic slide projector rests on a stand, directed at a wall about nine feet away. There's the familiar mechanical click as the carousel turns and a slide drops out of the tray in front of the machine's lit bulb. The image: a petite hand holds a photograph of a radiant sunset, golden rays bursting through puffs of clouds, against an actual horizon where the sun is also setting. The photo sun masks the real sun; the latter's gleaming rays are reflected in the watery foreground, as if emanating from the one in the picture. Every five seconds, the next slide drops; another sunset, and then another, fifteen in all, until the sun has set in both the photographed and local versions. The cycle from sun on the horizon to blackness takes less than a minute and a half. Then it begins again.

One of the pleasures of Lisa Oppenheim's *The Sun is Always Setting Somewhere Else* (2006) is the endlessly captivating enjoyment of a sunset reflected in the sea: the inevitable melt over the horizon, celebrated in a last-gasp burst of splendid orange-red light enveloped in velvety blue. No matter how clichéd, it inspires wonder at the sublime beauty of the mundane, a spectacle that cannot be produced, only found by chance. While the waning of the light might symbolize decline, its cyclical nature also marks the moments to a new day. In a metaphorical mirror, the brisk carousel circuit creates a loop; the sunset is presented in a sort of primitive time-lapse, each slide a film frame.

Projecting slides tends to blur images, producing a faint watercolor effect. In Oppenheim's piece, it softens the contours of the scene, which are already slightly out of focus given the shallow depth of field. After the initial impact of rhapsodic color, it's possible to detect clues to location in the photographs held against the sky: flat desert landscapes with silhouetted soldiers and tents, possibly a tank on the horizon? It's hard to make out—the small figures recall awestruck staffage in a Romantic vista by Caspar David Friedrich or William Turner. The brilliant sunsets in the photos tend to outdo the muted gray-blues and pinks of the actual seascape setting. There, buoys delineate a swimming area, and a pleasure craft bobs into the frame in some of the later slides, suggesting a place of leisure and recreation that contrasts starkly with the hints of war and exotic flora in the snapshots.

Oppenheim appropriated the sunset portraits from images posted on Flickr by U.S. soldiers in Iraq and Afghanistan, at the height of the wars started by George W. Bush after the attacks of September 11, 2001.[1] Upon her return from living in Europe for two and half years, the artist

was struck by the lack of coverage of the wars in the United States, as well as by the soldiers' online posting of innocuous, postcardlike sunsets for their families at home. These images are more souvenir than reportage, intended to reassure rather than enlighten. The slide-show format of the resulting work, its projection size equivalent to the portable living-room screen of old, recalls the classic use of this technology, as a relatively inexpensive way to present a kind of freeze-frame movie of a family trip, each slide a trophy of a place bagged by the tourist. The use of photography within the context of family, as a sort of domestic propaganda to cement familial bonds—and, in the case of travel photos, souvenirs of idyllic time spent together as enlightened explorers of another culture—is thus reinforced in the form of the piece as well as the images appropriated.[2]

The title, *The Sun is Always Setting Somewhere Else*, is a literal description: we see a series of faraway sunsets, "somewhere else," in front of a local one, thereby calling attention to a spatial disjunction with a temporal dimension. By rendering two different moments and places in each image, Oppenheim captures the uncanny aspect of photography, from which it derives its uniquely powerful affect, offering a fantasy that we can bridge a chronological gap, travel through time, and touch the past when we hold a photograph. Ultimately, of course, this is a false promise, but the astounding number of photos in existence speaks to a compulsive, and by definition, unsatisfiable desire. In Oppenheim's piece, she holds the anonymous appropriated image from Flickr in one hand while holding a camera with the other. This gesture implicitly underscores that all photos are authored, the product of a drive and of decision making, even if the subject is as happenstance and ubiquitous as a sunset. The cliché is cliché for a reason.[3] Some images still affect us no matter how many times we see them, and no matter how poorly made. Even if the faces of loved ones are unrecognizably shadowed, we cherish them through our faith in their indexical connection to the person pictured.

1 Lisa Oppenheim, "The Dark Side of the Moon," interview by Cecilia Alemani, *Mousse*, no. 16 (December 2008), p. 115.

2 For the sociological function of photographs, see Pierre Bourdieu, "The Cult of Unity and Cultivated Differences" (1965), in Bourdieu, et al., *Photography: A Middle-Brow Art*, trans. Shaun Whiteside (Stanford, Calif.: Stanford University Press, 1990), pp. 13–72.

3 It is interesting to note that, in French, the word *cliché* refers to a photographic negative, thus implying that a cliché expression is degraded due to overrepetition; in other words, by too many copies.

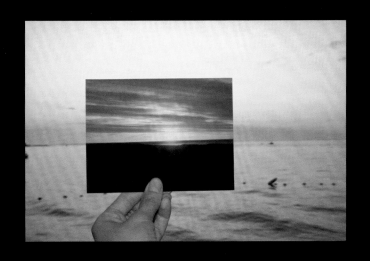

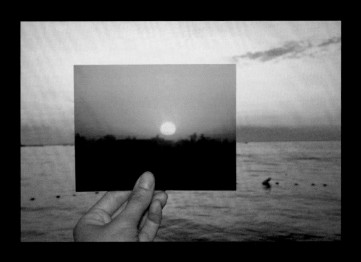

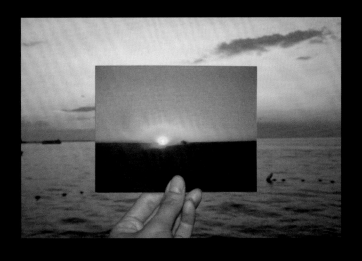

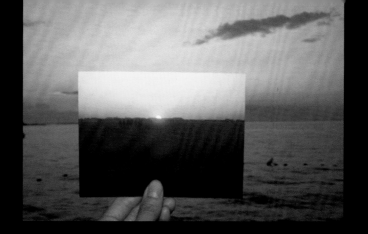

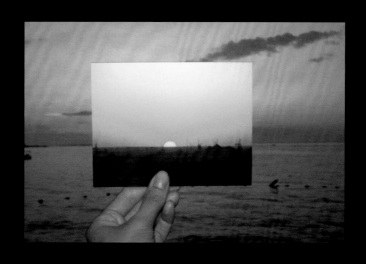

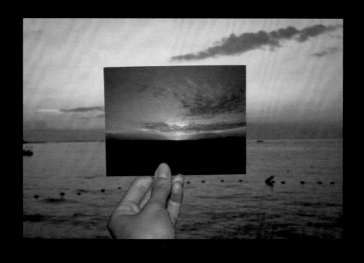

VII–IX

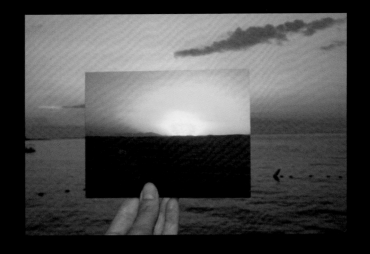

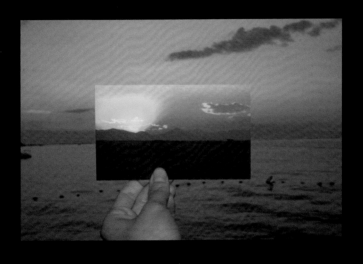

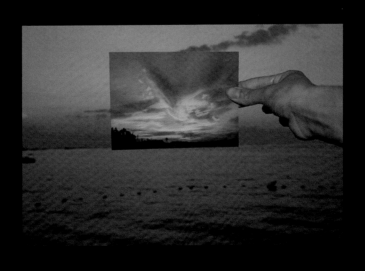

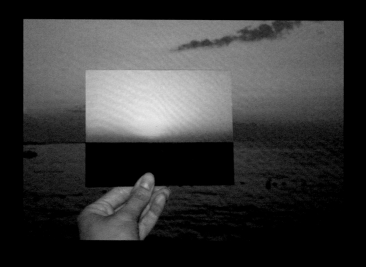

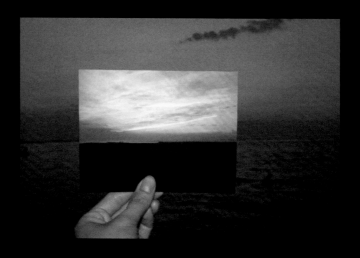

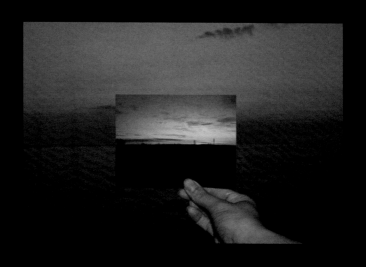

Oppenheim's use of the emphatic word *always* in the title of her slide show signals the inexorability of the solar cycle, and perhaps a yearning or homesickness for "somewhere else"—implying that the really good sunset is not the one in her backyard. Perhaps it is in the European locales she left behind when she returned to the United States, or it is among the amazing sunsets the troops send home? The title overall, *The Sun is Always Setting Somewhere Else*, also brings to mind the dated, stereotypical parental admonishment to a child who refuses to eat: "People are starving in Africa." Be grateful you are not a starving child in Africa, is the message—or a soldier in Iraq or Afghanistan. Oppenheim "brings the war home" by inserting the photographic reminder of distant conflict into an American landscape, that of her native New York, indicting a willful national ignorance.[4] Viewers can participate in this denial by cursorily enjoying the sunset, or instead, can look more carefully, or seek nondiegetic information, to understand what is pictured and what it might mean. Just as the troops exclude representations of the violence of war in their Flickr photos, Oppenheim does not reference it directly in this piece. Yet it is lurking there for those willing to see it, to face it.

Oppenheim created *The Sun is Always Setting Somewhere Else* in 2006, just as Kodak stopped manufacturing slide projectors.[5] The rise of digital cameras and image sharing via the Internet has precipitated the demise of virtually all film processes and products, including 35 mm slides. Oppenheim is less interested in lamenting this transformation, however, than in using photographic media against itself in provocative ways.[6] *The Sun is Always Setting Somewhere Else* incorporates the historical trajectory of slide technology to poetic effect while also pointing to the place of the image in contemporary life. The Internet provides

4 Consider Oppenheim's slide piece in dialogue with Martha Rosler's series *Bringing the War Home: House Beautiful* (1967–72), in which she collaged brutal news images from the Vietnam War into the luxurious settings of American shelter magazines. Oppenheim worked briefly for Rosler after college. See Brian O'Connell, "Between Appropriation and Reconstruction," *Art & Research* 1, no. 2 (Summer 2007), http://www.artandresearch.org.uk/v1n2/pdfs/oppenheim.pdf (accessed November 6, 2014).

5 Kodak discontinued production of slide projectors in October 2004:

http://slideprojector.kodak.com. Introduced in 1961, slide projectors reached the height of popularity in the 1970s. See https://www.kodak.com/ek/US/en/Our_Company/History_of_Kodak/Milestones_-_chronology/1960-1979.htm (both accessed December 6, 2014).

6 See Lisa Oppenheim, "Artist's Statement," in Mary-Kay Lombino, ed., *The Polaroid Years: Instant Photography and Experimentation*, exh. cat. (Poughkeepsie, N.Y.: The Frances Lehman Loeb Art Center, Vassar College; Munich: DelMonico Books, 2013), pp. 166–67.

the artist with a vast archive of images to mine and unique access to vernacular photographs. That these photos are tied to a specific moment in the medium's history has become more apparent since the piece was created, not only because of the obsolescence of the slide format but also because uploaded images shot by digital cameras such as the soldiers likely used were soon replaced by smartphone pictures. Each development in technology produces a specific type of image based on the capacities and limits of the devices. The lesson here is that every photograph is technologically time-stamped.

Photography was invented at the height of industrialization; its apparatus, the camera, is a mechanical device subject to innovation and the consumer-product life cycle. Thus the inexorably repeating sunset Oppenheim charts is also a metaphor for photography itself, every innovation a new sunrise followed by decline and renewal. Interestingly, Oppenheim's piece has an alternative incarnation online from whence it (partly) came, in the form of a PowerPoint slide show and Vimeo unfolding of the circuit of images.[7] And yet neither of these versions can replicate the experience of being in a room with a slide projector, hearing the clotted kick of the next slide, feeling the heat of the bulb and smelling the warmed film. What is the difference between carrying a photo of a beloved in your wallet and storing it on your phone? Perhaps it's the glowing screen that lets you see it in the dark, like a movie in a theater, or a slide show. But neither the digital portrait nor the snapshot is predicated on a communal physical space.

7 See http://www.artandresearch.org.uk/ v1n2/sunsets2.html and http://vimeo.com/ 76527933 (accessed October 14, 2014).

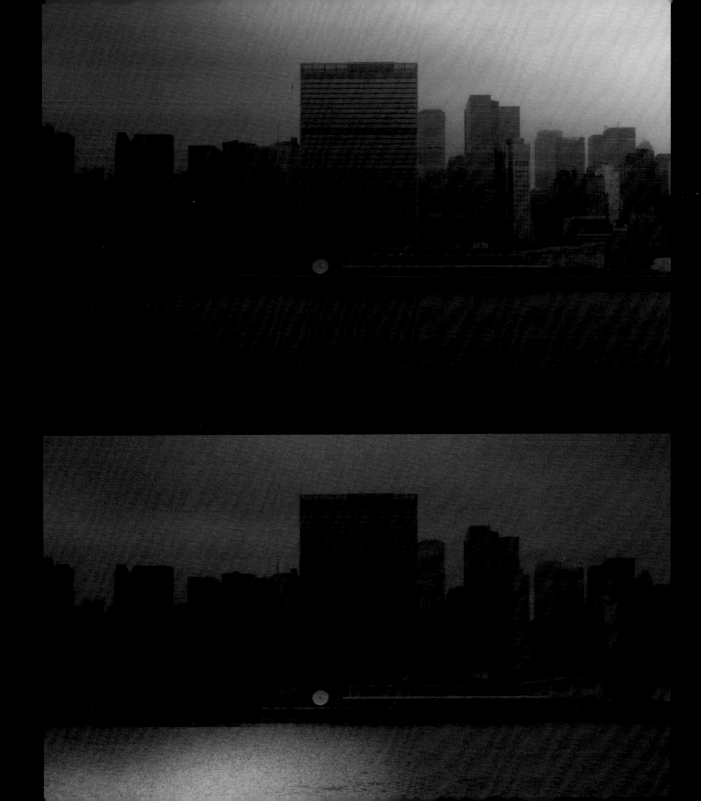

Erin Shirreff

UN 2010, 2010

LISA OPPENHEIM

Lisa Oppenheim's work investigates photography's material concerns, engaging the full breadth of its history and tracing the technological processes, consumption, and circulation of photographs from Henry Fox Talbot to Flickr. Oppenheim often draws source material from images found in institutional archives, such as the U.S. Farm Security Administration's trove of Depression-era photographs in the Library of Congress, which inspired the series *Killed Negatives (After Walker Evans)* (2007–09). Certain of Evans's negatives were ruled not fit for publication and were hole-punched, or "killed," by the editor. Oppenheim created images of similar scenes in an attempt to approximate content that might fill the absence left by the hole punch, printing only the portion of her photo that corresponded to the hole in the originals. Oppenheim's ongoing *Smoke* series similarly appropriates images in the public domain. The artist crops found photos of fires or explosions so that only the fields of billowing smoke remain, the resulting compositions resembling innocuous cloudscapes. The works' titles, taken from the captions accompanying the source images, retain references to the fraught circumstances those images capture. Solarizing the prints by exposing them with the light of an open flame, Oppenheim connects the content of the work to the process of its production. Compelled by photography's indexical relationship to its subjects, Oppenheim has also created series of photograms in which materials such as fine lace or ultrathin slices of wood operate as photographic negatives. Oppenheim was born in 1975 in New York, and graduated with a BA in modern culture and media with a concentration in art and semiotics from Brown University, Providence, Rhode Island, in 1998. She earned an MFA in film/video from Bard College, Annandale-on-Hudson, New York, in 2001, and participated in the Whitney Museum of American Art Independent Study program in 2003. Oppenheim lives and works in New York.
— Susan Thompson

SUGGESTED READING

Derieux, Florence, Krist Gruijthuijsen, and Bettina Steinbrügge, eds. *Lisa Oppenheim: Works 2003–2013*. Exh. cat. Berlin: Sternberg Press; Hamburg: Kunstverein in Hamburg; Reims: FRAC Champagne-Ardenne; Graz: Grazer Kunstverein, 2014. With essays by Karen Archey, Angie Keefer, Lisa Oppenheim, and Christian Rattemeyer.

O'Connell, Brian. "Between Appropriation and Reconstruction." *Art & Research* 1, no. 2 (Summer 2007), http://www.artandresearch.org.uk/v1n2/pdfs/oppenheim.pdf.

Oppenheim, Lisa. "Artist's Statement," in *The Polaroid Years: Instant Photography and Experimentation*, edited by Mary-Kay Lombino. Exh. cat. Poughkeepsie, N.Y.: The Frances Lehman Loeb Art Center, Vassar College; Munich: DelMonico Books, 2013, pp. 166–67.

——. "The Dark Side of the Moon." Interview by Cecilia Alemani. *Mousse*, no. 16 (Dec. 2008), pp. 112–15.

PLATES

I–XV
The Sun is Always Setting Somewhere Else, 2006 (details)
Slide projection of fifteen 35 mm slides, continuous loop, dimensions variable

XVI
A sequence in which a protester throws back a smoke bomb while clashing with police in Ferguson, Missouri. 2014/2015 (Tiled Version I), 2015
Two gelatin silver prints, exposed and solarized by firelight, 68.5 × 89 cm each

The large projected image, a portrait of a modernist building that dominates a cityscape, is big enough to convey the structure's monolithic presence, but not so large that the image can't be read as a picture, or a view from a window. The space housing the video isn't too dark to navigate, a bench is provided, and the projector mounted on the ceiling has been left visible. The subject is the thirty-nine-story United Nations Secretariat building in New York, designed by Oscar Niemeyer and finished in 1952. A vertical rectangle centered in the horizontal frame of the HD-standard 16:9 ratio shot, the UN is a flush geometric form, a perpendicular echo of the flat projection. The ragged skyline of smaller pre- and postwar buildings creates a motley backdrop for the gleaming modernist edifice. Though the projected image in the room doesn't create an immersive environment, the long view of the UN from across the East River, horizontally bracketed by equal proportions of sky above and water below, recalls the atmospheric scale of a nineteenth-century painting of a sublime landscape, or a twentieth-century Abstract Expressionist canvas.

As the video unfolds, the blue-cast light very gradually becomes more polychromatic, as if by the dawn, modeling the flanking buildings in contrast to the smooth turquoise surface of the United Nations. At various times in the seventeen-minute loop, sunlight from an unrevealed source appears directly over the building, or waxes and wanes across the scene. The video has no true beginning or end, and while initially it seems to record a diurnal-nocturnal circuit, it becomes apparent while contemplating the slow modulations in illumination that this is not, in fact, a video recording at all; rather, it is a static representation revealed through light. The first clue is that nothing in the image moves: a puff of steam from the roof of a building to the left of the UN never changes. A truck on FDR Drive doesn't budge, and neither do the glints of light shimmering on the wavy surface of the river, even though the sky above appears to change. Confirmation that the subject of the piece is a photo of the UN rather than the building itself—an object, but not the object initially perceived—is the way that, at times, light rakes over the surface of the image, materializing the texture and gloss of the paper support. Nor is there pattern to the imaginary sunrises and sunsets, and for brief moments inexplicable events occur that defy cosmic logic. For one second, a shocking, red-toned image of the scene appears, followed immediately by a blackout that only very gradually reveals a nocturnal view initiated by the suggestion of moonlight on the river. Several minutes

later, a romantic, almost black-and-white vista of the cityscape at night is visible for a few short seconds before a split-second burst of a gorgeous color version of a similar night scene flashes by so quickly as to seem a phantom, something imagined or perhaps a subliminal message.

The title of this piece is *UN 2010* (2010). The artist, Erin Shirreff, thus signals that time, both specific and durational, is at stake. The season seems to be winter, given that puff of steam at left, and the hint of trees barren of leaves along the waterfront. The photo was likely taken during the winter months at the beginning of 2010, or at the end of that year, in the season that bridges the annual calendrical seam. Like the looping form of the video, beginning and end are blurred in a kind of circuit with metaphorical value. Shirreff has said that she shot more than one hundred photos of the United Nations building, from which she selected several that she rephotographed in her studio, each new image transformed manually by lights and gels. Ultimately she used just a handful of these rephotographed photos to "choreograph" the video animation we see, which consists of transitional fades between the pictures.[1] In other words, the images are essentially handmade, and only assembled digitally.

UN 2010 refers nominally to a year in the life of the building, the one in which the base image was made, and as such it suggests a relatively long view of time—not a day, or a month, but a whole year. Concomitantly, the experience of the video is one of slowness, a contemplative time in which to feel minute variations. It suggests time-lapse cinematography, the twenty-four-hour circuit of the sun speeded up, though it was actually created through a process analogous to stop-motion animation. Shirreff is interested in quiet, prolonged duration as a means to be open to subtle experience, to perception that changes like the shifting light. In other videos and photographs, she has focused on midcentury abstract sculptures. For her, reproductions of sculptures, as opposed to the objects themselves, provide a distance that is expansive, that allows a unique access.[2] In *UN 2010*, she treats the building as

1 Shirreff frequently uses the word *choreograph* to describe her process. See, for example, "Erin Shirreff Takes Her Time," *Art21*, PBS, 2012: http://www.art21.org/newyork-closeup/films/erin-shirreff-takes-her-time/ (accessed October 14, 2014).

2 She cites specifically her response to a sculpture by Tony Smith, *New Piece* (1966). See "Mediated Objects: Jenifer Papararo in Conversation with Erin Shirreff," in *Erin Shirreff*, exh. cat. (Ottawa: Carleton University Art Gallery; Kingston, Canada: Agnes Etherington Art Centre; Vancouver: Contemporary Art Gallery, 2013), p. 64: "The remove offered by the reproduction opened up a contemplative space."

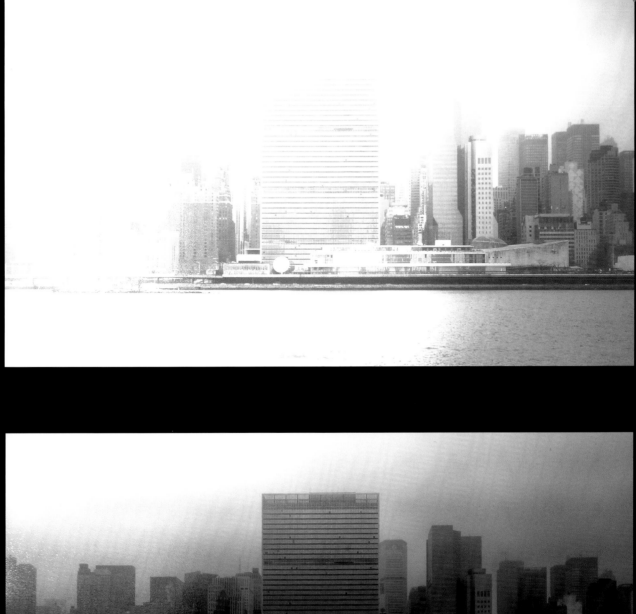
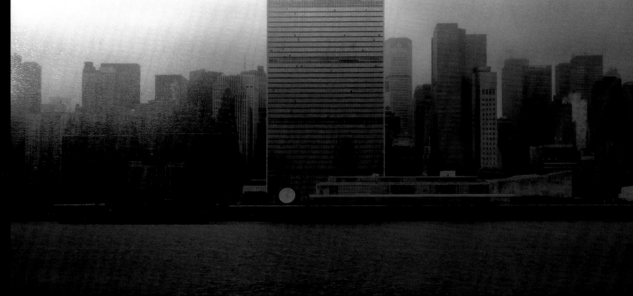

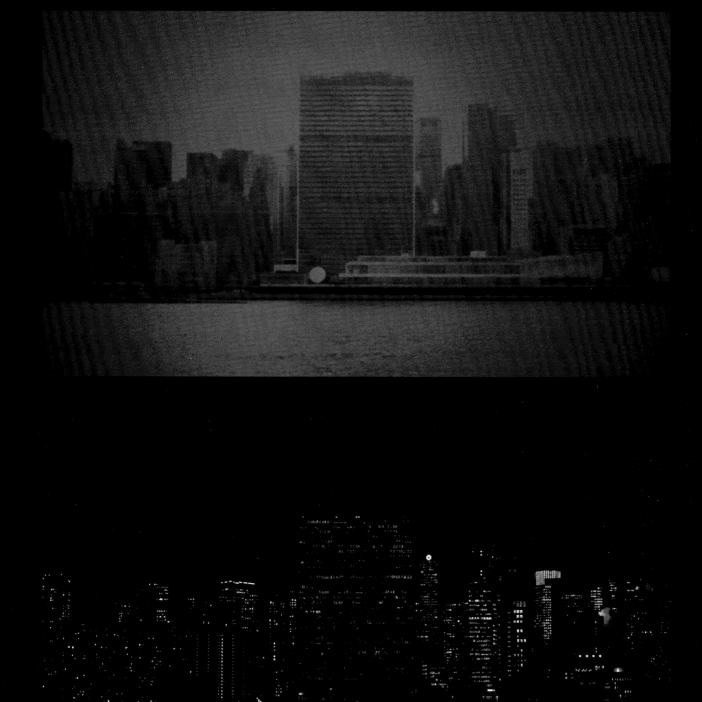

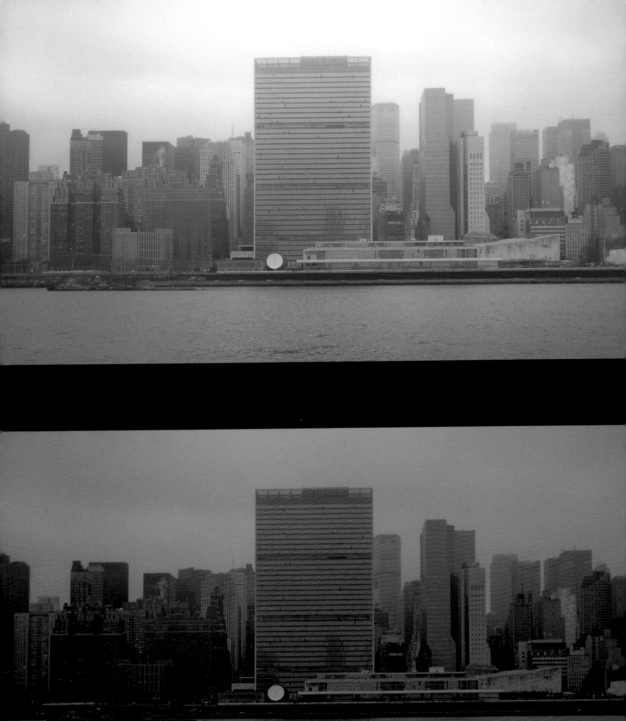

Erin Shirreff's work in photography, video, and sculpture reflects on the distance between an object and its representation, exploring the capacities of photography in conveying a sculptural experience. Since scale and presence were central concerns of much midcentury abstract sculpture, Shirreff often draws on images of such works as she explores the disjunction between photographs and their subjects. *Sculpture Park (Tony Smith)* (2006), Shirreff's first video work, features small cardboard maquettes the artist made of five Tony Smith sculptures. Filmed against a black background, their dark forms become discernible only as "snow" (Styrofoam) slowly accumulates on their surfaces. For more recent video works, including *UN 2010* (2010) and *Roden Crater* (2009), Shirreff photographed printed pictures of her subjects—often landscapes or iconic modernist buildings—under varying lighting conditions in the studio, inputting the resultant images into a video editing software. These videos appear at first to be long, static shots of the subjects pictured, but eventually belie their own artifice as the viewer becomes gradually aware of the texture of the image surface. Shirreff's ongoing interest in the photographic representation of large-scale abstract sculpture is reflected in her *A.P.* series. These photographs conjoin two half-images of miniature sculptures Shirreff crafted to echo the visual vocabulary of artists such as Alexander Calder, Anthony Caro, or Smith. The prints are folded at the seam of two images, suggesting a double-page spread of a book. Shirreff was born in 1975 in Kelowna, British Columbia. She earned a BFA in visual arts from the University of Victoria, British Columbia, in 1998, and an MFA in sculpture from Yale University, New Haven, Connecticut, in 2005. Shirreff lives and works in New York.
— Susan Thompson

SUGGESTED READING

Erin Shirreff. Exh. cat. Ottawa: Carleton University Art Gallery; Kingston, Canada: Agnes Etherington Art Centre; Vancouver: Contemporary Art Gallery, 2013. With essays by Jan Allen and Sandra Dyck, and an interview with the artist by Jenifer Papararo.

Meade, Fionn. "Time Lapse." *Kaleidoscope*, no. 8 (Fall 2010), pp. 54–59.

Shirreff, Erin. "Anthony Caro." *Art in America* 101, no. 11 (Dec. 2013), p. 94.

Vass, Michael. "Objects + Images: Erin Shirreff and the Grey Areas of Representation." *Canadian Art* (Spring 2014), pp. 72–77.

Weiss, Jeffrey. "The Absent Object: Jeffrey Weiss on Erin Shirreff's *Medardo Rosso, Madame X, 1896, 2013.*" *Artforum* 52, no. 2 (Oct. 2013), pp. 254–57.

PLATES

I–IV
UN 2010, 2010 (stills)
HD color video, silent, 17 min.

V
Sculpture Park (Tony Smith), 2006
SD color video, silent, 37 min.

VI
A.P. (no. 8), 2014
Inkjet print, 86.4 × 116.8 cm

the UN might evaporate in a flare of light or utter darkness, it always gradually reappears, from zero, as if with a new dawn, a presence as enduring as the stars.

a sculptural form, offering its facade as a kind of screen that mimics both the flatness of the photographic representation and its mode of presentation, projection on a wall. At the same time it provides a blank (abstract) face on which the viewer can project her own imagination.

UN 2010 can be read and enjoyed on multiple levels: there is the straightforward beauty of the visual image, the affective experience of its video form, and the intellectual complexity of its allusions. Though its pacing is largely meditative, its slow transitions are interrupted repeatedly by abrupt cuts that feel almost violent in their suddenness, obliquely suggesting a cataclysm. At these moments, it is especially hard not to recall the extensive video and photographic record of the 9/11 attacks, in which similarly modernist buildings not far from the UN were targeted for destruction.[3] The view of the WTC from my window that morning, across the East River, was comparable to Shirreff's perspective on the United Nations. And yet a flash of red followed by darkness, or glancing light that obliterates the image, can also recall other apocalyptic events, including the bombings of Hiroshima and Nagasaki. In this way, *UN 2010* seems to function as a kind of universal memorial to undefined traumas.

It is often stated that every photograph is commemorative, representing a past that no longer exists and yet continues to seem present in the uncannily spectral photographic image. Likewise, sculpture has traditionally been a means to remember both war victories and fallen soldiers. Maya Lin's *Vietnam Veterans Memorial* (1982) represents a turning point, away from figurative representations of heroism toward an affective abstraction enlisted to embody collective grief. Shirreff's *UN 2010* combines her attraction to midcentury abstract sculpture that is "independent from language" with her interest in the way the mediated image offers a space of contemplation, and perhaps even a way to manage the terrors of the real.[4] In her video, though

3 Is it coincidence that the video is seventeen minutes long, the time span between the first and second plane crashes into the North and South World Trade Center towers? Both buildings were initiated by Rockefellers, and known by their initials, the one dedicated to world peace and the other to world trade. The UN was evacuated during the confusion of events on September 11, 2001. Even the explicit dating of Shirreff's piece in the year 2010 can be seen as an assertion that it was produced in the aftermath of 9/11. Jan Allen contrasts *UN 2010* to Francis Alÿs's more explicit memorial, *Untitled (New York, September 2000)*, from 2001. See Allen, "Perception, Form and the Appetite for History," in ibid., pp. 60–61. Note that Shirreff never discusses specific readings of her work, leaving space for individual interpretations, an ethos of abstraction she clearly embraces.

4 Erin Shirreff, "Anthony Caro," *Art in America* 101, no. 11 (December 2013), p. 94.

Kathrin Sonntag

Mittnacht, 2008

I, II

The room is dark, illuminated only by the light beam of a slide projector. A new slide falls into place every ten seconds, which is long enough to scan each mysterious black-and-white image for clues. Eighty-one slides fill the carousel tray of Kathrin Sonntag's *Mittnacht* (2008); a full circuit in the continuous loop takes about thirteen-and-a-half minutes. As the slides drop, the setting becomes clear from fragments of furniture and equipment such as a light table, a broken lens filter and lens cap, slides in a box, electrical cords—a photographer's studio. The only illumination emanates, variously, from flashlights, a lightbox, a photo light mounted on a tripod, and a slide projector much like the one in the gallery. These glowing lights cast spooky shadows, suggesting it is *Mitternacht*, German for "midnight," the witching hour.

A key recurring element of this portrait of the studio after hours is the presence of photographic prints within the individual slides. Invariably these photos within photos appear to document some kind of paranormal event. There are scenes of levitation, séances, images of once-famous mediums and spiritualists, and pictures of psychic emanations such as ectoplasmic regurgitations and auratic handprints. These found images from the history of spirit photography, popular in the early years of the twentieth century, purport to represent the invisible, to provide evidence of ghosts in the realm of the living.[1] In Sonntag's piece, this appropriated photographic archive seems to have infected the studio, spawning little psychic miracles. A side table is tilted at a precarious angle, impossibly fixed in space without any kind of support, mimicking a photo depicting a similarly levitating table. A dried, goopy spill on a studio window echoes an ectoplasmic emission in a photo mounted on the wall nearby. Threadlike rays of light shoot from an eye or hand in a photo and extend out into the room. Mundane objects in the studio seem to have come to life, captured before they return to their quotidian functionality at daybreak.

In addition to these echoings, other forms of doubling occur in *Mittnacht*, to the effect of an incantation. Formal rhymes abound, between the parallel angles of sheets of glass and mirrors, the metal struts of work tables, and tripod legs. Small photographic prints often rest on sheets of glass, providing a transparent support on the same plane.

[1] Several of the images appear in Andreas Fischer and Veit Loers, eds., *Im Reich der Phantome: Fotografie des Unsichtbaren* [Realm of phantoms: Photography of the invisible] (Ostfildern-Ruit, Germany: Cantz, 1997), though Sonntag's research was conducted primarily on the Internet.

116

The insistence on oblique angles, which mirror each other in relation to the ninety-degree junctures of the walls and floors, creates a dynamic rhythm, propelling the viewer from one image to the next, always a little off-kilter but with a consistent logic, as if Constructivist or Bauhaus formal investigations were being conducted by a paranormal detective. Actual mirrors recur frequently, usually in the form of the rectangular household type that fit the back of a door, but sometimes as a square sheet angled in relation to a similar-size transparent glass pane. The reflections mirror the space of the studio or complete a bisected image, doubling reality and literalizing the ontological structure of the photograph as an index of the real, linked inexorably to its referent like a shadow. In some cases, the photos within the slide images defy logic to act as mirrors, seeming to reflect the studio in which they reside.

It is possible to simply enjoy the formal play of contrasts in *Mittnacht*—black/white; light/dark; transparency/reflection; void/solid—and yet each of these properties also operates conceptually. Analog photography is characterized by these dialectical pairs: negative film vs. positive print, obverse vs. reverse of the image (particularly in terms of slides but also negatives), upside down vs. right side up, double exposure. Mimicking the way photography copies reality, one scene of *Mittnacht* incorporates a photo of a broken plate; in a subsequent slide the broken plate is visible on the floor of the studio. The artist's photograph imitates the spirit photo in that it documents an occurrence the source of which is unknown; thus it is a sort of photographic double of an event.[2] By definition, photography is a medium that produces multiple copies of an original, all doubles or reflections. Additionally, the appropriated spirit photos in *Mittnacht* are reincarnations of the historical pictures. In Sonntag's slides, inexplicable streaks, craquelure, and spots on the film mimic phantom markings in the source photos.

Initially, the spirit photos read simply as geometric forms within the compositional structure of the studio. It is when we puzzle over their subjects that complications develop. There is something troublingly

2 The broken plate also echoes a spirit photo of a boy in a pantry surrounded by broken crockery. This image appears twice; the second time the boy is covered by a photo portrait of a girl, an image that itself is making its second appearance. The very self-referentiality of *Mittnacht* is also a sort of doubling. Note the odd historical spirit photos (two of which also appear in *Mittnacht*) interspersed with uncanny everyday shots in Sonntag's artist book *Les yeux sont ils fermés ou ouverts* (Are the eyes closed or open, 2006). The cover of this book appropriates a handwritten inscription on a spirit photo reproduced as the frontispiece of *Im Reich der Phantome*.

III, IV

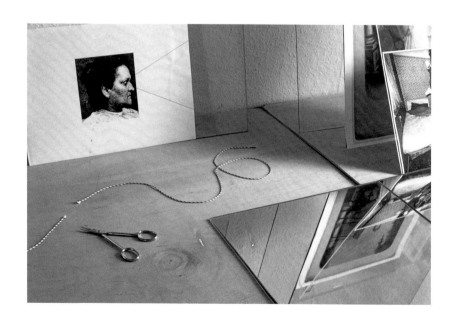

V, VI

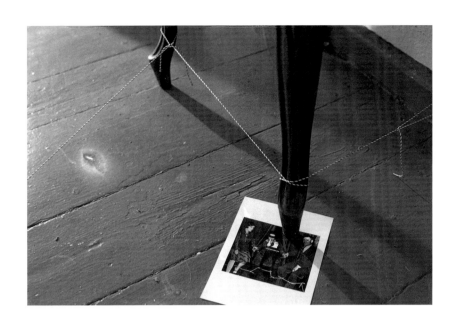

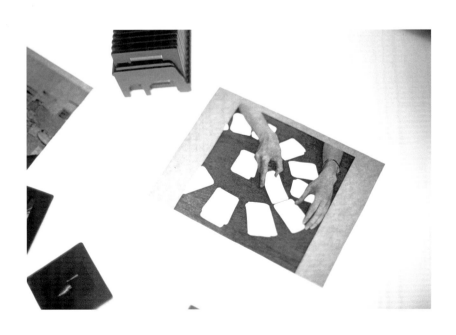

VII, VIII

IX, X

wrong in these photographs. Figures are semitransparent or two-dimensional; furniture and women defy gravity; strange auras appear around hands. As these odd goings-on are replicated in the space of the studio—as legs of chairs are tied together as in a photo, for example—it becomes clear that these second-order interventions are not quite the same. The illusion is broken by the visible string holding a title card spelling "MITTNACHT" in one slide, which clues the viewer into looking for strings or other trickery in the spirit photos. Similarly, what had at first seemed to be a photo of a photo turns out to be a reflection of a photo on a mirror. This process of sorting out first impressions, of doubling back and recategorizing perception, is integral to the piece.

The playfulness and abstract elegance of *Mittnacht* is underwritten by the depth of Sonntag's research into the nature and history of photographic representation. The work's formal and conceptual rigor highlights the way that the uncanny is articulated in photography, as a mimetic double of the real. The most commonplace definition of the uncanny, as the familiar made strange, easily fits *Mittnacht*. But it is a more complex intellectual dialogue in which the piece engages. Two slides give a hint of this, one at the beginning and one at the end of the carousel loop, suggesting a circuit around the studio that begins and ends in the same place: the artist's desk, covered with utensils and, notably, books, including Anthony Vidler's *The Architectural Uncanny*. This influential volume appeared in 1992, at a time when the psychoanalytic notion of the uncanny was employed by academics and critics to understand many types of modernist and contemporary art production based in recording technologies, from Surrealist photography to horror films to Cindy Sherman's work.[3] Vidler and others relied on Sigmund Freud's articulation of the uncanny in his 1919 essay "Das Unheimliche" as something both "homey" and not, familiar and yet vaguely sinister.[4] In his essay, which focuses on an analysis of the E. T. A. Hoffmann story "The Sand-Man," Freud notes the particular uncanniness of doubles,

3 See, for example, Rosalind E. Krauss, "Corpus Delicti," in her *L'Amour fou: Photography and Surrealism*, exh. cat. (Washington, D.C.: Corcoran Gallery of Art; New York: Abbeville Press, 1985), pp. 55–100; and Barbara Creed, *The Monstrous Feminine: Film, Feminism, Psychoanalysis* (London: Routledge, 1993).

4 Sigmund Freud, "The 'Uncanny,'" ("Das Unheimliche," 1919), in *The Standard Edition of the Complete Psychological Works of Sigmund Freud*, trans. J. Strachey, vol. 17 (London: Hogarth Press, 1955), pp. 218–52. In *Camera Lucida: Reflections on Photography* (New York: Hill and Wang, 1981), p. 79, Roland Barthes describes the photograph's "perverse confusion between two concepts: the Real and the Live."

such as twins, automatons, mirror reflections, and ghosts—all figures of replication, a type of reproduction.

The double is an emblem of the tension between the living and the dead, reality and fantasy, fact and fiction, truth and illusion, all of which are embodied in every photograph. But these binaries are particularly troubled in spirit photography, with its focus on the *para*normal and the invisible made visible. In *Mittnacht*, Sonntag presents a catalogue of uncanny doubling—in photographic form, in the architectural space of the studio, within the archive of spirit photographs. Sonntag also has a love of onomatopoeia, foreign words, and puns—in doubling within language.[5] *Mittnacht* focuses on the double meaning of *mediums*, both spiritual intercessors between two worlds and the (photographic) means through which ideas are expressed. Even the title of the piece replicates this liminal juncture, the edge between two worlds or two meanings, in its reference to "*mitt-*," or "mid-," the middle of the night, the line between the night and day, the border between nocturnal and diurnal.[6] Using all the devices of her craft, Sonntag creates a dizzying house of mirrors. But ultimately her goal seems less to disorient, trick, or instill fear, and more to create a fun house, a mind trip or riddle for the viewer, a perceptual game, a celebration of both/and rather than either/or.

5 See, for example, her exhibitions, *I See You Seeing Me Seeing You*, University of Dundee, Scotland, 2014; *Double Take*, Galerie Kamm, Berlin, 2011; and *Superkalifragilistigexpialigetik*, Gesellschaft für Aktuelle Kunst, Bremen, 2009; as well as the photographs *Flic-flac #1–3* (2009), not to mention the complicated wordplay in her German-language titles.

6 In fact, Sonntag's title is mysteriously missing the "er" in *Mitternacht*, the proper German word for *midnight*.

WASSILY KANDINSKY (1866-1944)

Stumpfes Grau

Signed with the initial and dated *K. (lower left); inscribed *No. 610, "Stumpfes Grau"* (on the reverse)

Oil on board

13 5/8 x 9 1/4 in. (34.5 x 23 cm.)

Painted in 1930

PROVENANCE

Galerie Flechtheim, Berlin

Sidney Janis Gallery, New York

Kunsthalle, Bern

Acquired from the above by Dr Gustav...

EXHIBITED

Berlin, Galerie Alfred Flechtheim...

New York, Sidney Janis Galle...

Bern, Kunsthalle, 1955, no...

KATHRIN SONNTAG

Experimenting with light, shadow, mirrors, and unexpected compositions, Kathrin Sonntag's images and installations destabilize visual perspective and make everyday items appear strange. Sonntag's pictures confound perception of illusionistic space and undermine assumptions about truth in photography. Much of Sonntag's work is situated in the space of the studio. Over the course of eighty-one slides, *Blame it on Morandi* (2011) provides a 180-degree view of the studio arranged in a series of vaguely uncanny still life vignettes. For the installation *Double Take* (2011), Sonntag covered one wall of a gallery in photographic wallpaper printed with a full-scale image of the studio's interior, creating a convincing and disconcerting trompe l'oeil. Many of the eighty-one slides in *Mittnacht* (2008) incorporate an image related to paranormal phenomena into a disorienting arrangement in the studio. As in many of her works, the eye takes a moment to identify and orient the objects pictured and to decode their spatial relationships. In 2009, Sonntag was awarded the Dr. Georg and Josi Guggenheim Prize. The primary reference for the artist's subsequent exhibition was the Christie's catalogue from the auction of the Guggenheims' modern art collection after their deaths. The images that comprise *Annex* (2010) depict the catalogue opened to various spreads and arranged in casual tableaux around Sonntag's studio. The objects placed on or near the book's pages find visual affinities and echoes in the modernist masterworks pictured within. Born in Berlin in 1981, Sonntag attended the University of the Arts, Berlin, from 2000 to 2006, earning a BA and an MA of visual arts. Sonntag lives and works in Berlin.
— Susan Thompson

SUGGESTED READING

If Only You Could See What I've Seen…, Exh. cat. Dundee, Scotland: Duncan of Jordanstone College of Art and Design, University of Dundee, 2014. With an essay by Sophia Yadong Hao.

Kathrin Sonntag: Green Doesn't Matter When You're Blue. Exh. cat. Aspen, Colo.: Aspen Art Museum, 2013. With essays by Jacob Proctor and Ryan Schafer.

Meade, Fionn. "Mirror and Stage." *Mousse*, no. 25 (Sept. 2010), pp. 94–101.

Sonntag, Kathrin. *Dracula's Ghost.* Genk: FLACC, 2009. With an essay by Sonntag and an interview by the artist with Nicolae Paduraru.

PLATES

I–X
Mittnacht, 2008 (details)
Slide projection of eighty-one 35 mm slides, continuous loop, dimensions variable

XI
Annex #18 – Kandinsky, 2010
Chromogenic print, 70 × 47 cm

Sara VanDerBeek

From the Means of Reproduction, 2007

A delicate mobile armature of looped metal wire and knotted white cord suspends seven black-and-white photographic images counterbalanced by ceramic rings and round disks, all set against a white ground. Sara VanDerBeek's *From the Means of Reproduction* (2007) is a photograph of photographic reproductions that initially appear to float in space before the handmade structure to which they are affixed reveals itself, by the ever-so-small hints of shadow cast by string onto paper, or a glint of light on the curve of a tubular bead. The chromogenic print records the variety of tones in the reproductions: though all black-and-white at first glance, one is cast a cool, slightly purple-pink while another is warmish yellow.

A medley of circular forms recurs in the appropriated images, echoing and mirroring one another and the ceramic rings. Starting at the top, a prominent round disk is mounted on the head of a bronze statuette in a grainy photo of an Etruscan hand mirror, its handle a draped female figure.[1] Below this photo is another subject from antiquity, a pair of sculptures of draped females, probably household deities, who reflect each other's poses and reiterate that of the figure above as well: each has one hand raised as if to make an offering, while the other hand daintily lifts up her skirt. Two photographs with circular motifs are counterbalanced below the goddesses. At left is a fisheye image of a metropolis, a microcosm defined by the circulation of its arterial roadways. The distortion of the camera's wide-angle lens results in a round, cropped image that appears convex, in contrast to the concave hand mirror above. At right, its complement is a pre-Columbian artifact that resembles an Art Deco pendant, with a stepped motif recalling classical meander frieze while also echoing the swallowtail folds of the goddesses' sculpted drapery. A level down from this image is David Smith's eight-foot-high sculpture, *Zig IV* (1961), its gently graduated, curving planes ziggurat-like modernist descendents of the artifact. Suspended from this photo are a crescent-shaped ceramic fragment and a disk, with shapes seemingly abstracted from the photo from which they dangle.

1 VanDerBeek identifies some of the images in this work in Ian Berry, ed., *Amazement Park: Stan, Sara, and Johannes VanDerBeek*, exh. cat. (Saratoga Springs, N.Y.: The Frances Young Tang Teaching Museum and Art Gallery at Skidmore College; Munich: DelMonico Books, 2012), p. 18: "The piece moves through time from top to bottom, beginning with an Etruscan hand mirror, to a statue of a Roman couple, to an image of a hanging circular construction by Rodchenko, to a fisheye view of a metropolis, to the image of the pill at the bottom." VanDerBeek describes other images as a "pre-Columbian artifact" and "David Smith's sculpture *Zig*." Sara VanDerBeek, e-mail to the author, February 23, 2015.

To the left, across from this structure, hangs another handmade ceramic ring and disk, balancing a reproduction of Alexander Rodchenko's *Hanging Construction* (1920), a modern mobile orrery. Finally, at the bottom of VanDerBeek's piece hangs the largest reproduction: a grainy, dramatically lit image of what appears to be a monolithic round sculpture. Above it is suspended a translucent square of plastic framing a circular cutout void, the quasi-invisible whiteness opposing the inky black shadow on the dimensionally rendered disk below it, which seems to be in eclipse, like a moon. The portrait orientation of this last image, like that of the uppermost in the composition, is analogous to that of the picture itself, a primarily white photographic print encased in a black frame.

The massive form anchoring VanDerBeek's photo is in fact a birth-control pill shot in close-up that appeared in *Life* magazine in 1970. Its macrocosmic portent was no doubt intended to convey the Pill's dramatic social impact.[2] The artist has indicated that the title *From the Means of Reproduction* refers to a speech by Margaret Sanger, the mother of the reproductive-rights movement, founder of Planned Parenthood and instigator of the invention of the birth control pill. Thus the mobile, with its anthropomorphic symmetry, may on some level be seen as a portrait of Sanger. And yet the photographic reproductions incorporated into the piece, while arguably representing the chronological arc of Sanger's lifetime (1879–1966), elicit another reading of the title connected less to Sanger or a physiological metaphor.[3] Like her father, the artist Stan VanDerBeek, Sara is a scavenger and collector of pictures. In pieces such as this, the "means of reproduction" includes incorporating photos from her father's archive as well as her own. Stan VanDerBeek

2 "The new doubts about the Pill," *Life*, February 27, 1970, p. 28. VanDerBeek maintains the crop as found in the magazine, where the right side of the pill crosses the gutter. The caption reads: "Though the average Pill weighs only a fraction of an ounce, American women consumed more than 5,000 tons of them last year." The *Life* archive is now available online: http://books.google.com/books?id=6lAE AAAAMBAJ&pg=PA28&source=gbs_toc_r&-cad=2#v=onepage&q&f=false (accessed October 14, 2014). *Life* was a picture-driven weekly magazine, inspired by German pioneers of the format like *Berliner Illustrirte Zeitung (BIZ)*, that was founded in 1936 and discontinued weekly publication in 1972 with the rise of television news.

3 In this reading, the old photos of ancient sculptures (the draped female handle of the Etruscan mirror and the two household goddesses) recall the voluminous turn-of-the-century dresses Sanger wore as a young woman. But they may also date to the reproductions themselves, products of the neoclassical taste popular in that period. The chronological trajectory proceeds from a more traditional form of femininity, to an oblique reference to the New Woman in the Art Deco–like artifact (chronologically paralleled by New Vision photos), to the apotheosis of the birth-control pill and sexual liberation, Sanger's major accomplishment at the end of her life.

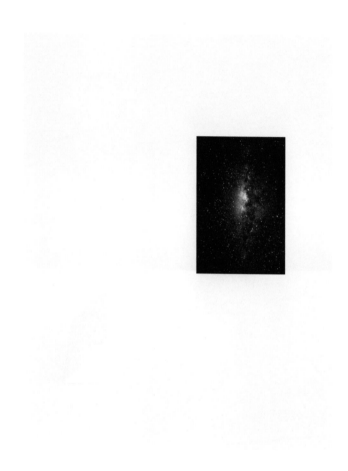

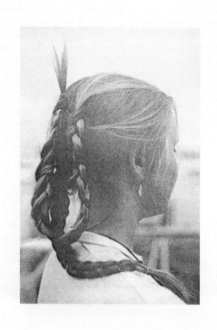

died when his daughter was only seven years old; she and her brother, the artist Johannes VanDerBeek, have labored painstakingly to preserve his legacy, in the process getting to know their father, both professionally and personally, in a way that was prevented by his early demise.[4] This kind of affection, and the yearning to connect to the past, is often embodied in photographs, which become precious talismans, so that the mobile, if it is a portrait of any person, is also a memento dedicated to lost time.

Created in the wake of 9/11, the body of work Sara VanDerBeek exhibited in her first solo exhibition, 2006's *Mirror in the Sky,* was noted for its memorial quality, the way the pictures mounted on armatures in her pieces recalled the photos of loved ones affixed to fences and walls around New York.[5] In her hands, this form of homage is a productive form of mourning, an elegy—in which the relics and reminders of the past are incited to remember and honor, the beauty of the form a sort of consolation and reverence. Her approach to appropriation, like that of many of her contemporaries, is less concerned with the questions of the previous generation of artists—authorship and originality, or critiques of media stereotypes—and more engaged with the position of the collector, the fan, the curator, or the archivist intent on gathering and preserving.[6] In the face of the Internet's torrential rush, she rescues material images and their histories from the rapids of oblivion, giving them new life and suggesting through her metaphorics of circularity that rejuvenation and revivification are as much a part of the cycle as disappearance and invisibility.

VanDerBeek has described memory as akin to the layers of windows on a computer screen, a collage metaphor that informs her practice.[7] It is difficult to determine scale in *From the Means of Reproduction,* based as it is on photographic images that include macro and micro views of their subjects. This variation suggests that differences in size

4 The exhibition and catalogue *Amazement Park* is a testament to this filial engagement.

5 See "First Take: Anne Ellegood on Sara VanDerBeek," *Artforum* 52, no. 4 (January 2007), p. 216. "Mirror in the sky" is the first line of the Fleetwood Mac song "Landslide" (1975), written and sung by Stevie Nicks, which is followed by the question, "What is love?"

6 Sara VanDerBeek, e-mail to the author, April 1, 2010: "I include images of artworks out of reverence for the artists, as they are usually a starting point of reference for my work and reflect my studio practice. However, their key reference is to time."

7 Ibid.: "The overall fractured nature of this digital interface, the computer screen, and the layering of windows on it, combined with the generally fragmented way of living today, is influential to the way that I organize and assemble these works."

refer less to reality and more to the relative import of each picture, how its impact looms large or recedes in memory. It highlights the difference between the artist's consciousness and the algorithms that determine what we receive when we search a topic online. VanDerBeek presents an idiosyncratic take on writing history that accommodates and encourages the viewer to step into her narrative. That hers is a motivated recounting is obvious by the highly determined rather than random nature of the associations she creates. Frequently, she references the impact of women whose contributions are at risk of being lost, such as Sanger, and especially artists, including Eileen Gray, Sonia Delaunay, and Lee Miller, to suggest that we gain access to the means of production through reproduction, in every sense of the word. This strategy is akin to that of the art historian, who speaks through her interpretations.

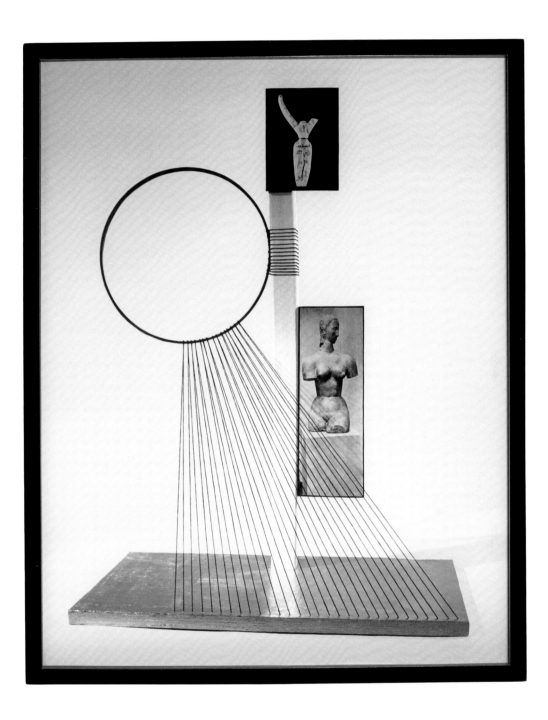

SARA VANDERBEEK

Sara VanDerBeek first became known in the mid-2000s for photographs featuring her own makeshift sculptural configurations in which appropriated photos were combined into collages that resounded with personal and political meaning. Constructed in the studio out of found images and pieces of wood, metal, and string, these works were created solely for the camera and were disassembled after being photographed. In a 2010 solo exhibition at the Whitney Museum of American Art, VanDerBeek showed a body of work composed of photographs she took of urban architectural details in New Orleans and Baltimore alongside images of simple sculptures created in the studio. Smaller in scale and more muted in palette, these works took their inspiration from passages in Walt Whitman's *Leaves of Grass* (1855), reflecting the artist's ongoing interest in poetry. VanDerBeek has become increasingly concerned with viewers' experience of the exhibition space, and has begun to incorporate sculptural elements, such as concrete columns, into her installations. In 2013, VanDerBeek traveled to France and Italy to photograph remnants of ancient sculpture, framing many of the resulting photographs with deep blue, semitransparent Plexiglas or mirrored glass. A nod toward the brightly painted surfaces of sculpture in antiquity, this gesture also calls further attention to the conditions of viewing. A recent group of studio-based still-life arrangements featuring photographs and white plaster geometric prisms references the work of E. E. Cummings and explores the inevitable layering and fracturing of time as it passes. Born in Baltimore in 1976, VanDerBeek earned a BFA from the Cooper Union for the Advancement of Science and Art, New York, in 1998. She lives and works in New York.
　— Susan Thompson

SUGGESTED READING

Berry, Ian, ed., *Amazement Park: Stan, Sara, and Johannes VanDerBeek*. Exh. cat. Saratoga Springs, N.Y.: The Frances Young Tang Teaching Museum and Art Gallery at Skidmore College; Munich: DelMonico Books, 2012. With essays by Anne Ellegood, Fionn Mead, Gloria Sutton, and dialogue among Berry, Johannes VanDerBeek, and Sara VanDerBeek.

"Conversation: Sarah Charlesworth & Sara VanDerBeek, A Space in Between." *Flash Art* 45, no. 285 (July–Sept. 2012), pp. 80–83.

Ellegood, Anne. *Hammer Projects: Sara VanDerBeek*. Exh. brochure. Los Angeles: Hammer Museum, 2011.

"Interview with Sara VanDerBeek." By Brian Sholis. Aperture blog. May 6, 2013, http://www.aperture.org/blog/interview-with-sara-vanderbeek/.

Kukielski, Tina. *Sara VanDerBeek: To Think of Time*. Exh. brochure. New York: Whitney Museum of American Art, 2010.

Sara VanDerBeek: Sensory Spaces. Exh. brochure. Rotterdam: Museum Boijmans Van Beuningen, 2015.

Sholis, Brian. "Sara VanDerBeek: Compositions." *Aperture*, no. 202 (Spring 2011), pp. 56–61.

PLATES

I
From the Means of Reproduction, 2007
Chromogenic print, 101.6 × 76.2 cm

II
Moon, 2015
Chromogenic print, 61 × 45.1 cm

III
Universe, 2015
Chromogenic print, 61 × 47 cm

IV
Incidence, 2015
Two chromogenic prints, 61 × 43.8 cm each

V
Sister, 2015
Chromogenic print, 61 × 47 cm

VI
Eclipse I, 2008
Chromogenic print, 51 × 41 cm

Afterwords

Composing close readings of ten artists' work is a multiply motivated act. On the first order, it is a way for me, as a curator, to immerse myself in the art, in looking and thinking about it, in order to parse out the intuitive logic of bringing these particular artists together in an exhibition. It is an attempt to pose as both amateur and expert in order to understand how the work communicates, and to whom. The process is also a model demonstrating how to look, a way to approach visual objects, and one that implicitly acknowledges that any interpretation is subjective and characteristic of the various subject positions we each inhabit.

All the artists in *Photo-Poetics*, along with many of their contemporaries, incorporate found photographic images into their work. This kind of appropriation is at least as old as the modernist technique of collage, but it is especially associated with Pictures generation artists active in the late 1970s and 1980s.[1] Sherrie Levine's riffs on Walker Evans's work, initially posited as a radical critique of authorship, authority, and originality, are now recognized as embodying all those things as well as a fan's desire and a love of the image-object.[2] Appropriation thus can be a way to gain access by taking a kind of possession, recognizing and replicating, and in the case of this younger generation of artists, (re)photographing.

The indexical quality of the photograph, the way it is umbilically linked with its subject, gives the photographic image a special power.[3] The photo's referent haunts it, seems to be present today and yet is

1 For a history of these artists, see Douglas Eklund, *The Pictures Generation, 1974–1984*, exh. cat. (New York: Metropolitan Museum of Art; New Haven, Conn.: Yale University Press, 2009). For the critical role of feminist artists associated with the Pictures generation, see Johanna Burton and Anne Ellegood, *Take It or Leave It: Institution, Image, Ideology*, exh. cat. (Los Angeles: Hammer Museum; Munich: DelMonico Books, 2012). See also Sarah Charlesworth's remarks in "April 2008/Panel Discussion: Remembering and Forgetting Conceptual Art: Sarah Charlesworth, John Divola, Shannon Ebner," in *Words Without Pictures* (New York: Aperture, 2010), pp. 138–50.

2 Though the richness and complexity of Levine's gesture was recognized by astute critics from the outset, Johanna Burton contextualizes changing interpretations of the artist's work, arguing that the subjectivity of the viewer is at the ontological core of Levine's practice. See Burton's "Sherrie Levine, Beside Herself," in *Sherrie Levine: Mayhem*, exh. cat. (New York: Whitney Museum of American Art, 2012), pp. 18–39.

3 See Roland Barthes, *Camera Lucida: Reflections on Photography* (New York: Hill and Wang, 1981), p. 81: "A sort of umbilical cord links the body of the photographed thing to my gaze: light, though impalpable, is here a carnal medium, a skin I share with anyone who has been photographed."

a specter from the past. Each photograph forms a metaphorical membrane between the temporality of the subject and the viewer in a more visceral way than other kinds of representation. The artists in *Photo-Poetics* carefully preserve the history of the images they appropriate by clearly presenting the book, magazine, or postcard that bears the reproduction, or by foregrounding the material facts of its paper support—by depicting the glare of light on the surface of a print, accentuating the signs of photomechanical reproduction or age (yellowing, wear and tear). In other words, they aren't presenting ahistorical or "timeless" images but rather very pointedly indicating that these pictures were born in specific contexts. Through appropriation, they are touching the past and connecting themselves and us to it.

By combining multiple images in one piece, or various typological samples in a series, these artists use pictures to create lexicons. The resulting collage aesthetic, characterized by the evocative potential of juxtaposition, simultaneously references manifold histories and temporalities through three-dimensional scaffolds for images and the durational mediums of film and video. Appropriated images speak for and are spoken by the artists in *Photo-Poetics* to create "a kind of deflected self-portraiture," a means to represent the self more as a subjectivity or subject position, a part of a community rather than as a particular individual.[4] When their personal histories are implicated in their work, it is obliquely, and not in order to elicit pity in response to the revelation of past traumas but rather an empathic recognition of shared experience. This manner of effacement, of avoiding overt self-description, has ethical ramifications that reflect the postmodern feminist critique of representation.[5] By including references to the contexts in which the images originally circulated, the artists implicitly compare the past to the present, and in so doing foreground the stereotyping and reductive objectification that often characterizes depictions of the Other (as defined by gender, race, sexuality, and class). At the same time, showing the mechanics of repression affords a kind of pleasure, the pleasure of

4 "Anne Collier," interview by Aimee Walleston, *The Last Magazine*, no. 1 (Fall 2008), p. 14.

5 See Craig Owens, "The Discourse of Others: Feminists and Postmodernism," in Hal Foster, ed., *The Anti-Aesthetic: Essays on Postmodern Culture* (Seattle: Bay Press, 1983), pp. 57–82. Near the end of Moyra Davey's video *Les Goddesses* (2011), she says, "And that is when I started taking pictures, at the very moment when the truth claims of the photograph were being dismantled by theory. That moment of the 'Discourse of Others' has passed or shifted, but it marked me, changed for good the way I work." Davey, "The Wet and the Dry," in *The Social Life of the Book* (Paris: Paraguay Press, 2011), p. 30.

making visible the invisible, similar to owning and thereby denaturaliz-ing derogatory epithets. When these artists can't find photographs that speak to or of them, they have to make them.[6]

By highlighting the original context of the representations they mine and reframing them, some of the artists in *Photo-Poetics* stage a confrontation between the desire that motivated the initial iteration of the image and their own. What does it mean when an artist appropri-ates a picture in such a way? For one, it can mean we witness her strug-gle to understand her desire in relation to the image, which she presents as a text to be read in tandem with the viewer. Desire can be unruly, and the reader/viewer/receiver of the image can recognize and identify with a desiring subject, even if the nature or object of desire is not shared. For many of the artists in *Photo-Poetics*, the love that they speak is not part of a sexual economy but rather a kind of familial or platonic love, a pas-sion that is no less strong or poignant for not having been sufficiently theorized by psychoanalysis.[7] Theirs is a reverence for the images and the artists who create them; their desire is to touch and connect.

While there is a memorial quality to all the work, which is inevita-ble with any photographic art, it is not nostalgic: it does not mourn the past or the loss of certain notions of subjectivity or social relations any more than it grieves the demise of obsolete photographic technol-ogies. Instead, it mines these histories to tell stories and write poems that sometimes celebrate and revivify the past, at other times lament it, but always offer lessons for the present, if not the future, of a legacy with which we must contend and ignore to our peril. These artists seem to argue not that it is the end of history but rather that history is spiraling, and we are doomed to repeat it unless we analyze and mark our trajectory.

Like archaeologists, these artists sift through the ruins of the past in order to understand the present. They offer curious relics that inspire us as viewers to question what they might mean. Archaeologists com-bine varieties of evidence—fragments of mundane objects, architecture,

6 See Leslie Hewitt, quoted in Randi Hopkins, "Time/Frame: Leslie's Hewitt's *Riffs on Real Time* (2006–2009)," in *Leslie Hewitt*, exh. brochure (Boston: Institute of Contemporary Art, Boston, 2011), n.p.: "I came to photography thinking of it as an object, something tangible, and something that you're not always included in; you may be looking through someone else's eyes or through someone else's gaze."

7 *Camera Lucida*, Barthes's reverie on the power of photographs, centers on his rumina-tions of a beloved image of his mother as a child. Thus it focuses on a model of familial love. See Marianne Hirsch, *Family Frames: Photography, Narrative and Postmemory* (Cambridge, Mass.: Harvard University Press, 1997), and *The Familial Gaze*, ed. Marianne Hirsch (Hanover, N.H.: University Press of New England, 1999).

and bodies; bits of inscriptions, texts, and representations—in order to speculate about the culture from which they come. The artists in *Photo-Poetics* are researchers and speculators too, presenting their findings for review. It is up to the viewer of the work to read and interpret it. These are not images that one experiences with a swipe, followed by a laugh or a gasp, and then another swipe. They reward contemplation, slowing down, rereading and reconsidering. This does not mean that they are not of their time but rather that they may also feed a desire, in the face of the superficiality of the virtual, to have a meaningful engagement, similar to the kind of intimate encounter one can have with a book, by getting lost in its narrative, delighting in its form, and recognizing oneself in the author's perceptions.

It is not accidental that these artists are producing material photographic objects that include representations of printed matter at a moment when both photographs and books are increasingly immaterial, stored in glowing electronic devices rather than printed on paper. Many of the works in the show were made possible, in part, through Internet searches for source material, and each speaks to an idiosyncratic vision. Every day more and more arcane data is uploaded to the Web, but there still remain oceans of information that are undiscovered, seemingly unloved. The term *curator* is now designated for all forms of aggregation. And yet we are fascinated by passions that go beyond or outside the algorithms designed by programmers whose ultimate goal is to sell us what they think we want, to reinforce the products that represent the largest common denominators of mass desire. Each of the artists in *Photo-Poetics* presents the algorithms of their own, often obscure pleasures, the results of their searches manifested in visual poems. Their obdurately material artworks resist the maws of the "cat/porn industrial complex" that is the Internet.

Instead, their photographic images, whether moving or still, presuppose a viewer who engages physically with their work. This is not to say that these artworks cannot be enjoyed online, or to deny that the Web provides access to information that enhances their understanding. But that representational platform will not capture the full experience of the piece any more than virtual sex can rival the real thing. The book form is closer, in that it can be held and contemplated and the textures of type and paper stock enjoyed. Its tactility replicates the experience of holding a photograph in one's hands, whether a postcard or a snapshot.

The scale of the work is intimate. Most of the photographs offer close-up perspectives, renderings that emphasize the textures and tactility of surfaces, which are close to the actual size of the objects and settings they depict, presenting a world we understand and to which we can relate. A number of works literally feature the hands of the artists manipulating photographs, modeling an entrée for the viewer. All the photographic images share a kind of realism that familiarizes rather than estranges. Even those that flirt with the uncanny seem more interested in pointing to the inherent strangeness in the everyday rather than alienating, or presenting a nightmare of (sexual) confusion. They demonstrate how perception, like reading, can unlock meaning; how comprehension can unfold over time and is itself a form of pleasure. The work aspires to awe, not shock.

These are characteristics that demystify the work of art, that promote its accessibility. The world that is presented and the objects therein are modest, familiar, mundane; the stuff of daily life, personal. The tone is earnest, not ironic. It is at the same time complex and open to interpretation. The viewer is invited to engage not for a moment but for a life cycle in tune with the rhythms of the natural world, from dawn to dusk, the passage of time as charted by the light at midday, twilight, midnight. Do all these traits combined suggest the possibility of an *écriture féminine*, a feminine discourse? Certainly the artists in *Photo-Poetics* are writing themselves, their tastes, their desires, their subjectivities, into the annals of history. For them, appropriation is a form of dialogue across time.

This is work that speaks softly, eloquently, and persuasively. It is not bombastic or overbearing. It calls to be read and contemplated, like a poem. In the end, the ten readings in this book become an argument, a defense of the works, a call to their audiences to reserve space in the present cacophonous, competitive environment for our attention.

1

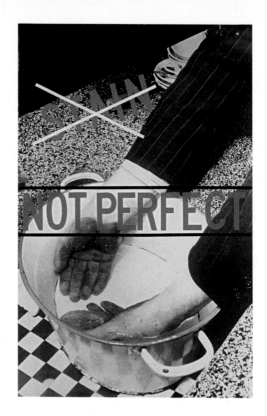

2

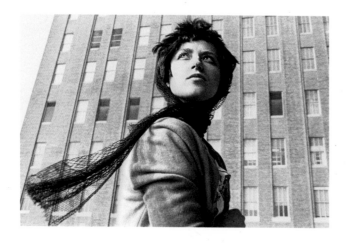

3

PARIS NEW YORK ROME TOKYO

4

5

6

AFTERIMAGES

1

Cindy Sherman (b. 1954)
Untitled Film Still #58, 1980
Gelatin silver print, 20.3 × 25.4 cm
Solomon R. Guggenheim Museum, New York;
Gift, Ginny Williams 97.4611

2

Barbara Kruger (b. 1945)
Untitled (Not Perfect), 1980
Gelatin silver print, paint, and tape, 152.4 × 101.6 cm
Solomon R. Guggenheim Museum, New York;
Exxon Corporation Purchase Award 81.2809

3

Sarah Charlesworth (1947–2013)
Herald Tribune: November 1977 (from the series
Modern History), 1977 (detail)
Twenty-six chromogenic prints, 59.7 × 41.9 cm each
Solomon R. Guggenheim Museum, New York;
Purchased with funds contributed by the
Photography Committee 2008.50

4

Louise Lawler (b. 1947)
Paris New York Rome Tokyo, 1985
Gelatin silver print, 74 × 84.1 cm
Solomon R. Guggenheim Museum, New York;
Purchased with funds contributed by the
Photography Committee 2005.17

5

Sherrie Levine (b. 1947)
After Rodchenko: 1–12, 1987/98
Twelve gelatin silver prints, 52.2 × 42.1 cm each
Solomon R. Guggenheim Museum, New York;
Purchased with funds contributed by the
Photography Committee; the Estate of Ruth Zierler,
in memory of her dear departed son, William S.
Zierler; and Pamela and Arthur Sanders 2006.76

6

Laurie Simmons (b. 1949)
Walking Camera I (Jimmy the Camera), 1987
Gelatin silver print, 213.4 × 121.9 cm
Solomon R. Guggenheim Museum, New York;
Purchased with funds contributed by the International
Director's Council and Executive Committee
Members: Ruth Baum, Edythe Broad, Elaine Terner
Cooper, Dimitris Daskalopoulos, Harry David,
Gail May Engelberg, Shirley Fiterman, Nicki Harris,
Dakis Joannou, Rachel Lehmann, Linda Macklowe,
Peter Norton, Tonino Perna, Elizabeth Richebourg
Rea, Mortimer D. A. Sackler, Simonetta Seragnoli,
David Teiger, and Elliot K. Wolk, with additional
funds contributed by the Photography Committee
2003.80

WORKS ILLUSTRATED

CLAUDIA ANGELMAIER

I
Betty, 2008
Chromogenic print, face-mounted to acrylic
130 × 100 cm
Solomon R. Guggenheim Museum, New York;
Purchased with funds contributed by the
Photography Committee with additional funds
contributed by Mr. and Mrs. Aaron M. Tighe,
and Rona and Jeffrey Citrin 2014.122

II
La Baigneuse Valpinçon, 2008
Chromogenic print, face-mounted to acrylic
193 × 144.5 cm
Courtesy the artist

III
Hase, 2004
Chromogenic print
110 × 200 cm
Private collection

IV
La petite Baigneuse, 2008
Chromogenic print, face-mounted to acrylic
56 × 42 cm
Courtesy the artist

V
Violon d'Ingres, 2005
Chromogenic print
130 × 100 cm
Courtesy the artist

ERICA BAUM

I
Jaws (from the series *Naked Eye*), 2008
Inkjet print
47 × 41.6 cm
Solomon R. Guggenheim Museum, New York;
Purchased with funds contributed by
Mr. and Mrs. Aaron M. Tighe 2011.48

II
Amnesia (from the series *Naked Eye*), 2008
Inkjet print
43.2 × 38.1 cm
Collection of Edward and Francine Kittredge

III
Picton Ceiling White Petals Leopard Square Chatter, 2014
Installation of four inkjet prints
78.7 × 228.6 cm overall
Courtesy the artist and Bureau, New York

IV
Nebulous 55 (from the series *Naked Eye*), 2011
Inkjet print
40.6 × 39.4 cm
Solomon R. Guggenheim Museum, New York;
Purchased with funds contributed by
Mr. and Mrs. Aaron M. Tighe 2011.49

V
Shampoo (from the series *Naked Eye*), 2008
Inkjet print
48.3 × 35.6 cm
Collection of Cheryl Donegan and Kenneth
Goldsmith

ANNE COLLIER

I
Crying, 2005
Chromogenic print
99.1 × 134 cm
Solomon R. Guggenheim Museum, New York;
Purchased with funds contributed by
Mr. and Mrs. Aaron M. Tighe 2005.47

II
Woman With a Camera (Cheryl Tiegs/Olympus 1),
2008
Chromogenic print
80.6 × 108 cm
Collection of Beth Rudin DeWoody

III
Open Book #2 (Crépuscules), 2009
Chromogenic print
112.1 × 149.9 cm
Courtesy Anton Kern Gallery, New York

IV
May/Jun 2009 (Cindy Sherman, Mark Seliger), 2009
Chromogenic print
102.2 × 127.3 cm
Collection of Mr. and Mrs. Aaron M. Tighe

V
Photography, 2009
Chromogenic print
144.8 × 127 cm
Collection of Michael Clifton, New York

MOYRA DAVEY

I, II, IV, V
Les Goddesses, 2011
HD color video, with sound, 61 min.
Courtesy the artist and Murray Guy, New York

III
Trust Me, 2011
Sixteen chromogenic prints, tape, postage, and ink
44.5 × 30.5 cm each
Collection of Laura Belgray and Steven Eckler

LESLIE HEWITT

I
Riffs on Real Time (1 of 10), 2006–09
Chromogenic print
76.2 × 61 cm
Solomon R. Guggenheim Museum, New York;
Purchased with funds contributed by the
Photography Committee 2010.53

II
Riffs on Real Time (2 of 10), 2006–09
Chromogenic print
76.2 × 61 cm
Solomon R. Guggenheim Museum, New York;
Purchased with funds contributed by the
Photography Committee 2010.54

III
Riffs on Real Time (3 of 10), 2006–09
Chromogenic print
76.2 × 61 cm
Solomon R. Guggenheim Museum, New York;
Purchased with funds contributed by the
Photography Committee 2010.55

IV
Riffs on Real Time (4 of 10), 2006–09
Chromogenic print
76.2 × 61 cm
Solomon R. Guggenheim Museum, New York;
Purchased with funds contributed by the
Photography Committee 2010.56

V
Riffs on Real Time (5 of 10), 2006–09
Chromogenic print
61 × 76.2 cm
Solomon R. Guggenheim Museum, New York;
Purchased with funds contributed by the
Photography Committee 2010.57

VI
Riffs on Real Time (6 of 10), 2006–09
Chromogenic print
61 × 76.2 cm
Solomon R. Guggenheim Museum, New York;
Purchased with funds contributed by the
Photography Committee 2010.58

VII
Riffs on Real Time (7 of 10), 2006–09
Chromogenic print
76.2 × 61 cm
Solomon R. Guggenheim Museum, New York;
Purchased with funds contributed by the
Photography Committee 2010.59

VIII
Riffs on Real Time (8 of 10), 2006–09
Chromogenic print
76.2 × 61 cm
Solomon R. Guggenheim Museum, New York;
Purchased with funds contributed by the
Photography Committee 2010.60

IX
Riffs on Real Time (9 of 10), 2006–09
Chromogenic print
76.2 × 61 cm
Solomon R. Guggenheim Museum, New York;
Purchased with funds contributed by the
Photography Committee 2010.61

X
Riffs on Real Time (10 of 10), 2006–09
Chromogenic print
76.2 × 61 cm
Solomon R. Guggenheim Museum, New York;
Purchased with funds contributed by the
Photography Committee 2010.62

XI
Untitled (Seems to Be Necessary)
(from the series *Midday*), 2009
Chromogenic print in custom maple frame
133.4 × 158.8 × 12.7 cm
Collection of Arthur and Susan Fleischer

ELAD LASSRY

I
Four Eggs, 2012
Chromogenic print in painted frame
36.8 × 29.2 × 3.8 cm
Solomon R. Guggenheim Museum, New York;
Purchased with funds contributed by the
Photography Committee 2013.71

II
Bengal, 2011
Chromogenic print in painted frame
36.8 × 29.2 × 3.8 cm
Solomon R. Guggenheim Museum, New York;
Purchased with funds contributed by the
Photography Committee 2013.70

III
Men (055, 065), 2012
Gelatin silver print in walnut frame
36.8 × 29.2 × 3.8 cm
Solomon R. Guggenheim Museum, New York;
Purchased with funds contributed by The Robert
Mapplethorpe Foundation 2013.62

IV
Heirloom Tomatoes, 2010
Chromogenic print in painted frame
36.8 × 29.2 × 3.8 cm
Courtesy the artist and David Kordansky Gallery,
Los Angeles

V
Woman (Camera), 2010
Chromogenic print in brass frame
21.6 × 26.7 × 3.8 cm
The Museum of Modern Art, New York.
Fund for the Twenty-First Century

VI
Portrait 1 (Silver), 2009
Gelatin silver print with applied silver foil in
aluminum frame, 26 × 21 × 3.8 cm
The Museum of Modern Art, New York.
Fund for the Twenty-First Century

VII
Untitled (Woman, Blond), 2013
Chromogenic print in walnut frame with four-ply silk
36.8 × 29.2 × 3.8 cm
Solomon R. Guggenheim Museum, New York;
Purchased with funds contributed by the
Photography Committee 2013.72

LISA OPPENHEIM

I–XV
The Sun is Always Setting Somewhere Else, 2006
Slide projection of fifteen 35 mm slides,
continuous loop
Dimensions variable
Solomon R. Guggenheim Museum, New York;
Purchased with funds contributed by the
Photography Committee 2009.60

XVI
*A sequence in which a protester throws back
a smoke bomb while clashing with police in Ferguson,
Missouri. 2014/2015 (Tiled Version I)*, 2015
Two gelatin silver prints, exposed and solarized
by firelight
68.5 × 89 cm each
Courtesy the artist and Tanya Bonakdar Gallery,
New York

ERIN SHIRREFF

I–IV
UN 2010, 2010
HD color video, silent, 17 min.
Solomon R. Guggenheim Museum, New York;
Purchased with funds contributed by Erica Gervais
2010.29

V
Sculpture Park (Tony Smith), 2006
SD color video, silent, 37 min.
Collection of the artist

VI
A.P. (no. 8), 2014
Inkjet print
86.4 × 116.8 cm
Ann and Mel Schaffer Family Collection

KATHRIN SONNTAG

I–X
Mittnacht, 2008
Slide projection of eighty-one 35 mm slides,
continuous loop
Dimensions variable
Solomon R. Guggenheim Museum, New York;
Purchased with funds contributed by the Photography
Committee and Manuel de Santaren 2011.15

XI
Annex #18 – Kandinsky, 2010
Chromogenic print
70 × 47 cm
Collection of Sheri B. Levine

SARA VANDERBEEK

I
From the Means of Reproduction, 2007
Chromogenic print
101.6 × 76.2 cm
Solomon R. Guggenheim Museum, New York;
Purchased with funds contributed by the Photography
Committee 2007.138

II
Moon, 2015
Chromogenic print
61 × 45.1 cm
Courtesy the artist and Metro Pictures, New York/
The Approach, London

III
Universe, 2015
Chromogenic print
61 × 47 cm
Courtesy the artist and Metro Pictures, New York/
The Approach, London

IV
Incidence, 2015
Two chromogenic prints
61 × 43.8 cm each
Courtesy the artist and Metro Pictures, New York/
The Approach, London

V
Sister, 2015
Chromogenic print
61 × 47 cm
Courtesy the artist and Metro Pictures, New York/
The Approach, London

VI
Eclipse I, 2008
Chromogenic print
51 × 41 cm
Collection of The Frances Young Tang Teaching
Museum and Art Gallery, Skidmore College,
Saratoga Springs, New York, Gift of the artist, 2010.9

The works reproduced in this volume are selected
from the checklist of the exhibition *Photo-Poetics:
An Anthology* as it was presented at the Solomon R.
Guggenheim Museum, New York, and the Deutsche
Bank KunstHalle, Berlin.